IMAGES
of America

ALLENDALE

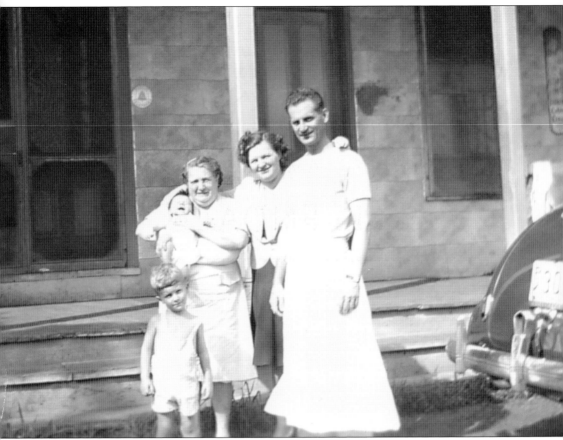

In 1945, tavern manager Maude Connelly stands in front of the Allendale Hotel holding grandson Bob. With her are daughter Marge, son-in-law Walt Kunisch, and grandson Michael. In 1947, Allendale Hotel owner Ethel Braun Maratene notified Maude Connelly she would have to leave the hotel. Connelly responded by purchasing 67 West Allendale Avenue, investing $26,000 to construct the bar and grill addition. A legal battle ensued, as Connelly wanted to have the liquor license transferred to her new tavern, while Maratene wanted to keep it for her new business venture. On September 11, 1947, after a public hearing at the firehouse, the council voted five to one for Maude Connelly to have the license transferred to her new tavern, soon to be known as the Allendale Bar and Grill. Cheering followed the decision. (Courtesy of Bob Kunisch.)

ON THE COVER: Travelers await the arrival of the train at the Allendale station around 1905. In 1848, with the help of surveyor Col. Joseph Warner Allen, rail service came to this farming community, later named Allendale in recognition of Colonel Allen's efforts. Travelers would come to the station via horse and buggy or bicycle. The Allendale Post Office was established in 1869, first located in the train station. It later moved to the Allendale Hotel, then back into the train station from 1902 to 1914. Residents would come to the station to pick up or send their mail. (Courtesy of Linda Keet Tillinghast.)

IMAGES
of America

ALLENDALE

Fred Litt
Foreword by Ari Bernstein

ARCADIA
PUBLISHING

Copyright © 2021 by Fred Litt
ISBN 978-1-4671-0686-3

Published by Arcadia Publishing
Charleston, South Carolina

Printed in the United States of America

Library of Congress Control Number: 2021932892

For all general information, please contact Arcadia Publishing:
Telephone 843-853-2070
Fax 843-853-0044
E-mail sales@arcadiapublishing.com
For customer service and orders:
Toll-Free 1-888-313-2665

Visit us on the Internet at www.arcadiapublishing.com

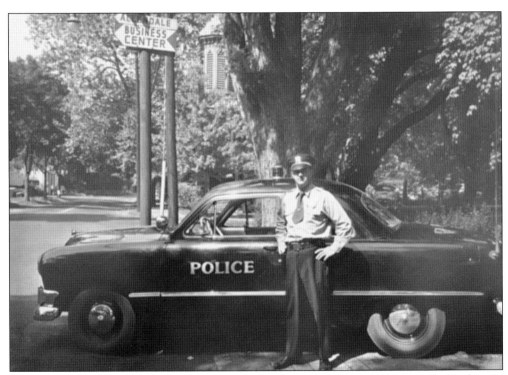

With Archer Memorial Methodist Church in the background, Allendale chief marshal Robert D. Wilson proudly stands in front of the borough's newest police car, a 1950 Ford Coupe. Authorized at the council's November 24, 1949, meeting, the car cost $732 plus trade-in on the police department's current vehicle, a 1946 Plymouth. In 1959, with the reorganization of the police department, Robert Wilson would become the borough's newest chief of police, serving until 1967. (Courtesy of Billy Wilson.)

CONTENTS

FOREWORD

I was born and raised in Allendale. Memories of swimming at Crestwood Lake, walks through the Celery Farm Nature Preserve, Fourth of July fireworks, and Memorial Day parades will be with me forever. I am one of those people who will not leave. Better said, I am part of that group of people that grew up here, understood and witnessed the charm and magic of Allendale, and looked to be a part of its future.

Allendale is a community of special people. The teachers of Hillside, Brookside, and Northern Highlands laid the groundwork for my success in college and law school. I owe so much to the coaches and local organization volunteers who taught so many of us the value of hard work, team spirit, and community service.

Although much of Allendale has been developed, it retains a small-town feel. I witnessed, firsthand, the selfless contributions, the willingness to fight and keep fighting to preserve the charm of Allendale and make it a great place to live and to raise a family.

Although voices are sometimes raised, Allendale residents will always join hands to commemorate important events and to recognize those who have contributed so much. The annual ceremony at Memorial Park to honor those who served and sacrificed and the gatherings at Crestwood Park to remember those lost on September 11, 2001, will live in my heart forever. These are the reasons why people like me do not leave.

I am honored and humbled to be the mayor of the borough of Allendale. As I said when I was sworn in as mayor on January 3, 2019, I am standing on the shoulders of giants and am deeply indebted to the men and women who made Allendale such a great place to live and raise a family.

As someone who grew up in Allendale, I am grateful for Fred Litt writing this book and capturing the rich history of our community in such vivid detail.

—Ari Bernstein
Mayor, Borough of Allendale, New Jersey

ACKNOWLEDGMENTS

This book would not have been possible without the support of dozens of history enthusiasts and longtime Allendale families. My effort to recover, preserve, and share Allendale's historic treasures was inspired by many friends and neighbors, including Marilyn Wilson Tackaberry, Jack Grosman (JG), Gloria and Rod Ruth, Billy Wilson, Lauren J. Hirsch, and Joanne Hart. Each provided personal collections as well as invaluable insight and guidance. Dozens of families who grew up in Allendale generously contributed envelopes and boxes filled with vintage documents, photographs, school records, maps, and so much more. Unless otherwise noted, all images appear courtesy of the author.

The best history is told by those who lived it. Personal diaries, contemporaneous news stories, and original documents are referenced to make the stories of Allendale come alive. Over the last 150 years, county historians and Allendale residents have written history books and commemorative booklets with amazing detail. They include Frank Berdan, Donald H. Brown, cartographer Claire Tholl, Brookside School class of 1945, the New Jersey Tercentenary Project Group, historians of the Archer Memorial Methodist Church, et al.

The Bergen County Clerk's Office provided access to original documents and surveys from Allendale's incorporation as a borough in 1894. The Allendale Public School Board of Education and Superintendent's Office provided facilities for me to review, photograph, and scan board of education meeting minutes and financial records from as early as 1890. The Allendale Ambulance Corps (AAC) and the Allendale Fire Department (AFD) each shared a huge container overflowing with historic treasures. Our Lee Memorial Library (LML) provided photographs of Allendale's first public library building on Franklin Turnpike and of library benefactors William and Mary Lee, after whom the current library is named.

The Allendale Historical Society (AHS), founded in 1974 by dozens of history enthusiasts with families who lived here for many generations, will be remembered forever for its efforts to document personal stories and to collect relics from Allendale's earliest times.

We must acknowledge the importance of history and the role of the historian. History is a collection of events from the past. Each event may be interesting, but it often has so much more to share. To help us make sense of these events, we need a historian.

The historian has two main objectives. The first is to identify the events and organize them into an enjoyable story. And then to provide the next historian with a road map to help them continue this never-ending journey back in time. Together, history and the historian teach us about the past, help us understand the present, and provide us with a guide how to approach the future.

Speaking of historians, we must all applaud the incomparable research skills and writings of Allendale historian emerita Patricia Webb Wardell. Her book *Allendale: Background of a Borough*, utilized here as a treasure map, is the standard every historian will only hope to come close to.

Given occasional disagreements among historians, I also play the role of referee, hoping to provide the most accurate review of the available facts. All events in this book have been researched—and researched again—using every available resource to provide the most accurate information. I hope you find the book fun and interesting. Best wishes are offered, in advance, to the historian that will create the next chapter of Allendale history.

—Fred Litt

INTRODUCTION

As this book is being written, the United States has elected a new president, political differences challenge national unity, and Covid-19 continues to impact every Allendale resident, business, and school. As such, it has never been a more important time to preserve local and national history and to listen carefully to the lessons they provide.

As detailed throughout the book, three events establish the foundation for the story of Allendale. First, in 1664, the English claimed the territory known today as New York and New Jersey, removing the Dutch, the first European empire to colonize this area. Despite a somewhat chaotic beginning, the English brought new settlers and developed local governments, including counties and townships. About 100 years later, the English were removed after the Revolutionary War. Second, the area had no nearby rail service. A train stop was needed here to provide farmers with new markets for their produce. Col. Joseph Warner Allen, a surveyor, helped develop the Paterson & Ramapo Railroad, which connected two nearby rail lines to bring rail service to the area. Dedicated in 1848, the new train depot was named Allendale in honor of his efforts. Lastly, as the train brought commuters and new homeowners to Bergen County, it also brought the need for paved roads, new schools, and modern services, such as streetlights and sidewalks. Bergen County communities, often defined by their school district, felt underrepresented within the township form of government. In 1894, an act of the legislature permitted a community to break off from its township and form a borough, requiring only a petition of qualified local residents. With this new legislation, aided by an onerous School Act of 1894, Allendale, along with dozens of other New Jersey communities, became boroughs. This event was known as "Boroughitis."

To properly introduce Allendale's history, it is important to first go back a few thousand years to learn about the origins of the state of New Jersey and Bergen County.

Archaeologists have demonstrated that over 10,000 years ago, a land bridge brought people from Asia to North America. Some of these travelers moved east, and 1,000 years ago, they settled along the Delaware River. These original people became better known as the Lenni Lenape or Delaware people. Their homeland provided good soil to grow food and waterways for fishing and transportation.

Meanwhile, from about 500 BC, Europeans traveled east, overland and by ship, to Asia to trade for exotic goods and to learn about foreign cultures. As sailing technology advanced, the hunt was on for a shorter route to the Far East. Sponsored by European empires, explorers headed in a new direction, west, via the Atlantic Ocean. Instead, they found North America. Beginning in the late 1400s, the Lenape probably greeted the parade of Europeans who visited the coasts and waterways of North America.

The explorers claimed their findings on behalf of their sponsors, which included the empires of England, the Netherlands, Sweden, and France. Upon returning home, the explorers were rewarded financially and encouraged to sail again to search for additional territories and treasures. In the early 1600s, the Dutch began to colonize the area known today as New York and New Jersey. As colonies grew, the Lenape presence declined due to disease, intertribal fighting, and being pushed out by the Europeans. Given their diminishing numbers, they sold their property to the Europeans and scattered throughout the western United States.

In 1497, John Cabot, an Italian explorer, discovered the coast of North America under the commission of King Henry VII of England. This gave England claim to North America. In 1524, Giovanni da Verrazano, an Italian explorer sailing on behalf of King Francis I of France, was the

first European to explore the Atlantic coast of North America from Florida to New Brunswick, including the New York bay. This gave King Francis I his nation's claim to the new world. In 1609, Henry Hudson, an English explorer working for the Dutch East India Company, sailed the ship *Half Moon* from the Delaware Bay up to Albany, along the river now named, what else, the Hudson River. Upon his return to the Netherlands, Hudson described what he had found: a magnificent harbor, wide navigable rivers, and a land rich in natural resources. The Dutch, of course, claimed the territory.

As a historical footnote, some explorers sailed again, not always providing the same good fortune. Verrazano, according to one story, was eaten by natives on the island of Guadeloupe. Henry Hudson's crew mutinied and set him adrift never to be seen again. Be careful what you ask for, I guess.

In the early 1600s, based on land claimed by Henry Hudson, the Dutch established New Netherland and colonized New Amsterdam (now lower Manhattan). Peter Stuyvesant became governor.

Taking advantage of John Cabot's earlier claim, England decided to seize New Netherland from the Dutch. On March 12, 1664, England's King Charles II granted to his brother James, Duke of York, a royal patent for the region between the Connecticut and Delaware Rivers, establishing a proprietary colony that included New Netherland.

That year, the Duke of York initiated an expedition to take New Netherland from the Dutch. With 450 men and four ships, the British navy, under command of Col. Richard Nicholls, seized the area for England. Dutch governor Peter Stuyvesant surrendered without firing a shot. England's new colony now extended from the Delaware River to the Hudson River.

The Duke of York then divided the colony into New York and New Jersey, reserving New York for himself as the "Duke's province." The city of New Amsterdam was renamed New York after the Duke of York. Colonel Nicholls was appointed governor of New York, serving until 1668.

On June 23, 1664, the Duke of York conveyed the area of New Netherland west of the Hudson River, the present state of New Jersey, to his friends Sir John Lord Berkeley and Sir George Carteret. It was stipulated in the conveyance that the tract should be called Nove Cesarea or New Jersey. This name was given as a compliment to Sir George Carteret for his defense of the Isle of Jersey during the English civil wars. With this, New Jersey's birth year was later officially established as 1664.

Berkeley and Carteret were given full ownership of the land. However, while the king granted his brother the duke the power of governing the area, the duke did not give his friends that same authority. Instead, the duke established Colonel Nicholls as the new governor, giving him the authority to administer New Netherland. Jurisdictional disputes arose between New York and New Jersey.

In August 1673, the Dutch recaptured New Netherland from the English, holding it for approximately six months before losing it again to the British in 1674. In 1676, a series of new agreements and patents divided New Jersey, with the "West" (South Jersey today) going to Berkeley and the "East" (North Jersey today) to Carteret. This division was finalized in the Quintipartite Deed, which authorized Berkeley and Carteret (and their appointees and successors) as proprietors. This allowed them to distribute land and to govern their territories.

On March 7, 1683, the Provincial Assembly passed an act creating four independent counties, Bergen, Essex, Middlesex, and Monmouth. The original boundaries of Bergen County consisted of modern-day Bergen, Hudson, and Passaic Counties as well as a small portion of Essex County (when Passaic was formed it also took a piece of Essex). On its northern border, Bergen County included a slice of Rockland County, New York, as far north as the area around Haverstraw. Bergen County's birth year was established as 1683.

The Township Act of 1693 divided counties into townships. Bergen County was divided into the townships of Bergen and Hackensack. In 1710, New Barbadoes separated from Aquackanonk Township in Essex County and joined Bergen County. Today's Allendale would have been in New Barbadoes Township at that time.

With the property owners of both East and West Jersey acknowledging their never-ending disputes, in 1702, Queen Anne took back the authority to govern New Jersey. Landowners

surrendered their charters to the Crown, reuniting East and West Jersey as a single royal province. The government now consisted of a governor and a 12-member council appointed by the British monarch, along with a 24-member assembly whose members were elected by qualified colonists, each of whom were required to own at least 1,000 acres of land.

In 1709, the area known as the Ramapo Tract, part of the original East Jersey, was purchased from the Lenape. This area included the future borough of Allendale. Around 1740, John Lauback and Powles Van Houten established homes in this area. At that time, Allendale would have been in Franklin Township.

William Franklin, son of Benjamin, became New Jersey's last royal governor in 1763, serving until 1776. William Livingston, a signer of the Declaration of Independence, was the first American governor of New Jersey, serving from 1776 to 1790. Following Delaware and Pennsylvania, New Jersey became the third colony to ratify the US Constitution, thereby becoming a state on December 18, 1787.

As the beginnings of New Jersey and Bergen County have been properly outlined, it is now important to discuss how counties were broken into smaller governments, called townships.

Borders often changed to maximize the political power of their included landowners. The center of Allendale community activity in the 1700s and 1800s would have been along Franklin Turnpike about where Archer United Methodist Church stands today. In 1710, that area would have been in New Barbadoes Township, within Bergen County. By 1772, the church would have then been located in Franklin Township.

On February 5, 1849, an act of the legislature formed Allendale's newest home, Hohokus Township, from parts of Franklin Township. By the 1870s, as townships became unwieldy to govern, landowners formed school districts to provide further local decision making and resources.

Early Allendale began to take shape as School District No. 55 within Hohokus Township. A new schoolhouse was built in 1862 on Franklin Turnpike near East Orchard Street.

On January 1, 1886, the Allendale community became part of Orvil Township, which was created from the western portion of Washington Township and the southern portion of Hohokus Township. It was named for Orville James Victor, a journalist and author who lived in the area.

However, Waldwick was the Orvil township seat, giving it superior political power. And so, as the need for a new school arose, where would it go? Waldwick, of course. The residents of Allendale were not happy.

In 1894, commuters and farmers, with vastly differently interests, decided to separate from their townships to form their own local governments, called boroughs.

The first chapter, "School Districts and Boroughitis," tells the story how the desire for better local resources encouraged the residents of School District No. 55 of Orvil Township to join with nearby landowners in Hohokus and Franklin Townships to form the Mayor and Council of the Borough of Allendale on November 10, 1894.

One

SCHOOL DISTRICTS AND BOROUGHITIS

Up until the mid-1800s, New Jersey was governed by counties and, within each county, by one or more townships. The township was the local government. Townships typically had an annual meeting each February where residents would debate and decide on local issues. In 1834, New Jersey has 125 townships, which typically had low taxes and little government. At that time, most property was farmland.

Two active rail lines bypassed areas of Bergen County that would later become Allendale. A connection to these existing rail lines would help farmers quickly transport their apple, peach, and renowned strawberry harvests to urban markets, which included Paterson and Newark. In 1844–1845, local officials accepted a proposal from Col. Joseph Warner Allen, a respected surveyor from South Jersey, to plot a connection to these existing rail lines. To encourage a train stop in the area, the Mallinson and Van Houten families, nearby landowners, provided the necessary land for the depot and rail line. Colonel Allen spent several years surveying and overseeing the development of the Paterson & Ramapo Railroad through this area. With his efforts, service joining New York, Paterson, and Ramapo to the Allendale area was completed and opened to traffic on Thursday, October 18, 1848. The rail project included a depot that had no formal name, but people started calling it and its hometown Allendale in tribute to the man who guided its development.

The arrival of farming families, the creation of Franklin Turnpike in 1806, and the new Allendale train depot in 1848 sparked tremendous change in the area. Better transportation brought day-trippers, commuters, and new markets for local growers. New homeowners, often coming from New York City, wanted schools, libraries, and houses of worship. Farmers wanted low taxes. These interests competed for political power.

Townships constantly changed their borders to best represent their landowners. To provide further local control, school districts were established within townships around nearby schools, post offices, and train depots.

Given the lack of planning, often several school districts would be established within a single township. With its many train stops, Bergen County had multiple school districts. Orvil Township, established in 1886, included five school districts, Chestnut Ridge (No. 24, 62 scholars), Saddle River Valley (No. 25, 90 scholars), Hohokus (No. 54, 106 scholars), Allendale (No. 55, 139 scholars), and Upper Saddle River (No. 59, 68 scholars).

Wealthy districts would compete with poorer districts for resources. New townships, changing borders, and new school districts created governing havoc.

School districts had little ability to bring tax dollars to their immediate area. In 1887, Allendale (i.e., School District No. 55) created the Village Improvement Association with A.L. Zabriskie as its president. This organization, known as the VIA, helped bring paved roads and street lighting to Allendale. To gain greater autonomy, a school district could break away from its township by becoming a borough form of government. However, the process required asking the state legislature to pass an act to establish a new borough. As this process was arduous and political, until 1875 only 17 boroughs had been created. As commuters gained political influence, they demanded a path to becoming a borough that did not require an act of the state legislature. And so, on April 5, 1878, the legislature passed the Borough Act, "An Act for the formation of Borough Governments," allowing landowners in an area less than four square miles and with fewer than 1,000 people to seek a referendum on secession from the township to become a borough. This referendum could take place with a petition of the owners of 10 percent of the land, as measured by value, in the area in question and within 10 days' notice of the vote. If approved, the borough would be governed by an elected mayor (serving a one-year term) and a six-member council (elected to staggered three-year terms).

In late 1893, given an economic depression and a national political upheaval, Republicans, backed by commuters, took control of the state legislature. A new Borough Act of May 9, 1894, was soon approved that supplemented the Borough Act of 1878. This new act added that a new borough that included portions of at least two townships could also have its own representative on the County Board of Freeholders. With this change, becoming a borough became more enticing.

However, it was the School Act of 1894 that created the mad dash to become a borough, forever known as "Boroughitis." This School Act wiped out the former subsidiary school districts and made each township a single school district. Orvil Township would shrink from five school districts to only one. Taxpayers were obliged to pay, pro rata, existing debts of the old districts in addition to all future debts of the township for school purposes. Allendale's School District No. 55 would suffer financially by the consolidation. Exempted from this provision were boroughs, towns, villages, and cities. And so, if a community became a borough, its school district would be independent, self-governing, and free of all previous township debts and gain a seat on the county board.

Fearing everyone else would flee to become their own independent borough, thereby leaving them holding the bag, Allendale area residents began the petition process to become a borough. On September 17, 1894, as required, with property owners from three townships representing at least 10 percent of the land value in the new borough and covering less than four square miles (actually 3 5/8), the following property owners signed the petition (with their appraised land value): Orvil Township—R.V. Ackerman ($1,500), O.H.P. Archer ($11,000), J.A. Mallinson ($2,600), William H. Mallinson ($2,500), and Louise Doty ($2,500); Franklin Township—Louis Rossner ($2,000); Hohokus Township—R.V. Ackerman ($2,500), Peter D. Rapelje ($2,000), Garret G. Smith ($500), and John A. and William H. Mallinson ($700).

On November 8, 1894, in the basement of Archer Memorial Church on Franklin Turnpike, qualified residents voted 100 to 11 to incorporate as the Mayor and Council of the Borough of Allendale. On November 10, 1894, Allendale was officially recognized as a borough. On April 2, 1903, with Walter Dewsnap as mayor, the council voted to shorten the name to the Borough of Allendale.

So what was the impact of the Borough Acts, the School Act, and the resulting Boroughitis? From 1894 to 1895, 40 boroughs were created, with 26 in Bergen County. The rush to form boroughs was slowed down (but not stopped) when the legislature quickly passed an amendment to the School Act that stated that no borough could maintain a school separate from the township unless there were 400 children within its limits. On March 26, 1896, the state passed a bill providing that "no borough or village hereafter be incorporated in this state except by special act of the legislature."

And now, in words and pictures, the history of the borough of Allendale begins.

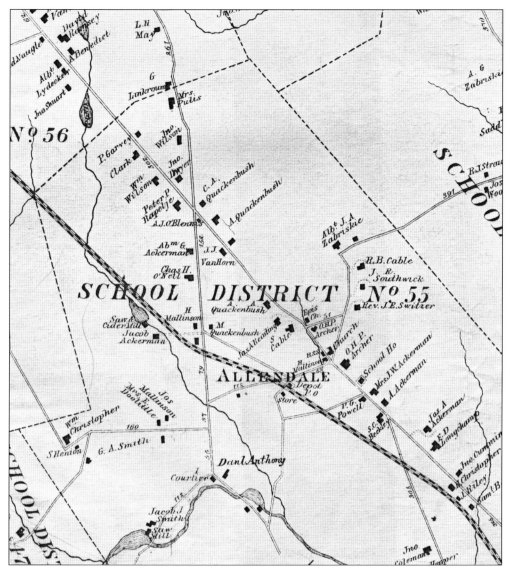

In 1849, Allendale became part of Hohokus Township. To support local community interests, school districts formed, centered around nearby train depots. School districts within Hohokus Township included eight school buildings with a valuation of $14,600 and a seating capacity for 587 children. The township was divided into eight school districts, named and numbered as follows: Hohokus, No. 54; Allendale, No. 55; Ramsey's, No. 56; Ramapo Valley, No. 57; Mahwah, No. 58; Upper Saddle River, No. 59; Masonicas, No. 60; and Riverdale, No. 62. Districts competed for local resources. In 1886, Allendale would become part of Orvil Township and compete with four other school districts for township resources. This map segment is from the *Atlas of Bergen County New Jersey, 1776–1876.*

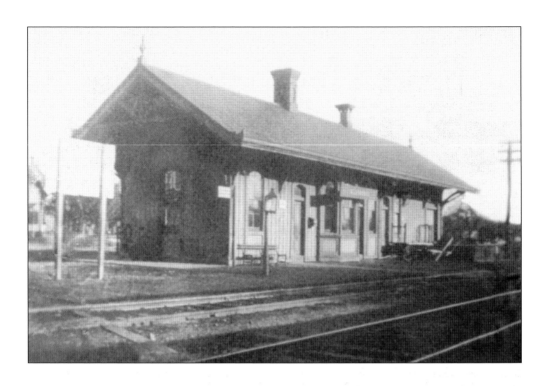

In the above photograph, the Allendale train station was first located on the east side of the tracks near the Allendale Hotel and shopping district. The original building fell into disrepair and was rebuilt in 1870. In 1902, the station was moved to the west side of the tracks. In the photograph below, taken around 1905, a train headed south has arrived at the station's new western location. The multicolored roof and the missing chimney reveal the modification of the station after its move.

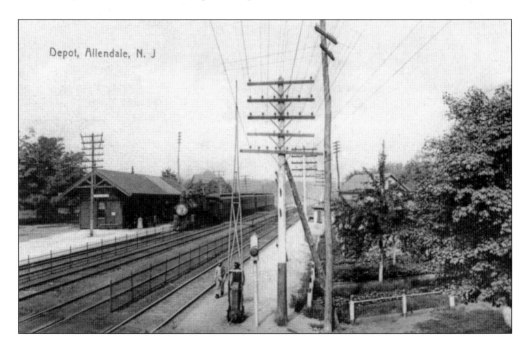

Depot, Allendale, N. J

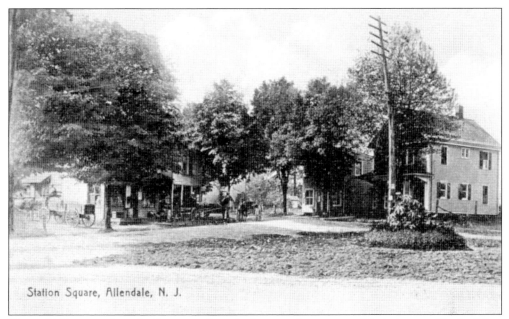

Station Square, Allendale, N. J.

This c. 1905 view is from the Erie train depot looking southwest toward Park Avenue. The building at left is Ackerman's General Store, which was started by Abraham Ackerman in 1869. His son Richard and then grandson John managed the store in later years. At right is 42 Park Avenue, still standing, then the home of Gaspirini's Allendale Shoe Repair.

This c. 1905 view is from what would be today's commuter parking area near the Allendale Hotel, looking in a northeasterly direction. The white fence at left marks the future site of the Braun Building, constructed in 1911 and later known as the Flatiron Building. The house at right was H.C. Borger's Dry Goods Store from about 1903 to 1914. It was moved to High Street in 1931.

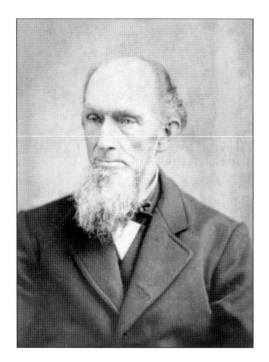
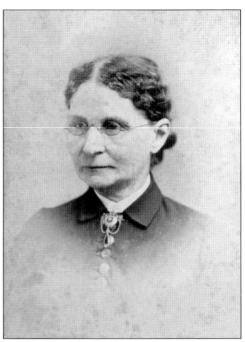

Peter Goetschius Powell and his wife, Maria Ackerman Powell, pictured above, owned 67 acres of property in 1889. Powell sold a lot on Franklin Turnpike to the board of education for $25 to build a new school in 1862. Their farmhouse, pictured below, was located near today's Powell Road and East Allendale Avenue. Maria Powell and her daughter Anna Elizabeth ran a boardinghouse in their homestead. The mansion was razed in the 1930s. (All, courtesy of Warren Storms.)

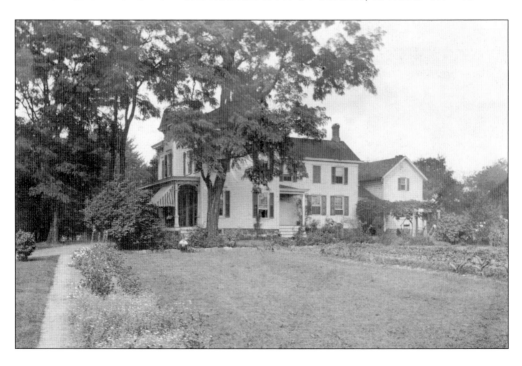

No. 6

Mr. Peter G. Powell

To the Township of Hohokus, Dr.

No. of Acres assessed, 57 Acres.

Value of Real Estate assessed. . . $

Value of Personal Property,

Sum to be raised, 81 Cents per $100.

To STATE TAX for 1869,	$	2.34
COUNTY TAX,		12.74
BOUNTY & INTEREST,		18.__
TOWNSHIP TAX,		2.08
SCHOOL TAX,		5.20
SPECIAL ROAD TAX,		7.8
POLL TAX,		1.00
DOG TAX,		.25
ROAD TAX,	$ 8.84	
CR. BY WORK,	8.84	
		43.37
TOTAL,	$	

Now due and payable to me before the first day of December next. The Commissioners of Appeal in cases of taxation will meet at the hotel of Henry B. Demarest, on the Fourth Tuesday of November, at ten o'clock, A. M.

Received Payment, _J H Hemion_ COLLECTOR.

Taxes will be received on the days named, as follows : On Thursday, the 25th of November, at the house of John L. Hering; on Friday, the 26th of November, at the house of Garret Bamper, Jr.; on Saturday, the 27th of November, at the house of William Christie; on Monday, the 29th of November, at the house of Henry B. Demarest, from 10, A. M., to 5, P. M., of each day.
☞ You are requested to pay your taxes by the first day of December, as all delinquents will be returned to a Justice of the Peace for collection after that day, according to law, or twelve per cent. added if not paid. No taxes will be received on election day at the polls.

JOHN H. HEMION.

In 1869, Peter G. Powell lived in Hohokus Township, within School District No. 55. In 1886, he would have paid his taxes to Orvil Township, and in 1895, the new borough collector, Richard V. Ackerman, would have collected Powell's taxes on behalf of the newly incorporated municipality known as the Mayor and Council of the Borough of Allendale. Ackerman collected borough taxes at his store near the Allendale train station. (AHS.)

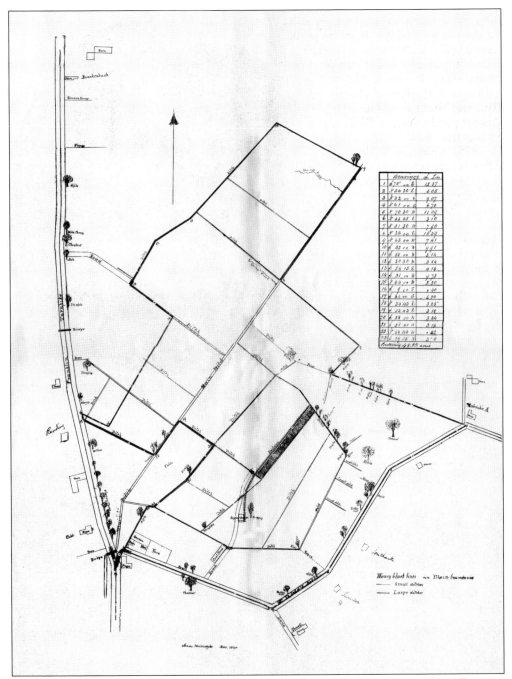

In 1867, Isaac Wortendyke surveyed the property along Franklin Turnpike and Saddle River Road (Cottage Place), then known as the Wolf Swamp. Purchased in 1866 by John J. Zabriskie of Hohokus to farm peat to be used as fuel, the property was sold to Henry J. Appert in 1888 to grow celery and onions. In 1981, the Borough of Allendale bought the property, now known as the Celery Farm. (AHS.)

Property owner Henry J. Appert was active in the community, serving as Allendale public school clerk, twice on the Allendale Board of Education, and two terms on the borough council. He was a director of the First National Bank and Trust Co. of Ramsey. Appert purchased the Wolf Swamp from John Zabriskie in 1888, renaming it the Allendale Produce Gardens. His farm grew lettuce, onions, and celery. After numerous owners, the 60-acre farm was purchased by the New Jersey Conservation Foundation and subsequently by the Borough of Allendale. Today, the property is best known as the Celery Farm, a wildlife sanctuary enjoyed by the public. (AHS.)

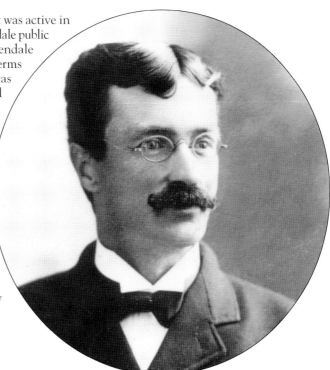

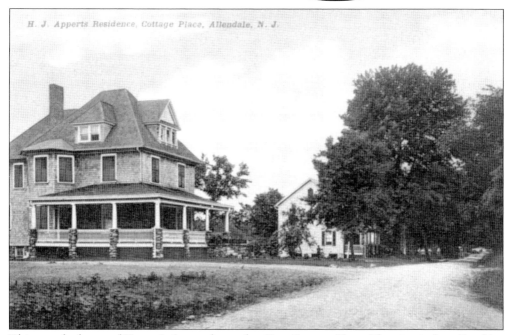

This was the home of Henry J. Appert located at One Cottage Place. The view is from Franklin Turnpike looking toward today's East Allendale Avenue. The Celery Farm begins behind the home at left. The original Appert residence burned to the ground; the rebuilt home is pictured here. In the garage alongside the house, the Catholic church held services from around 1903 to 1914 before it moved to a private home on Maple Street.

```
In the matter of a petition for the :
                                     :
formation of a borough government to be :   Certificate of
                                     :
known as "The Mayor and Council of   :       Election.
                                     :
the Borough of Allendale"            :
```

TO THE CLERK OF THE COUNTY OF BERGEN:

We, ALFRED E. IVERS, Clerk, and WILLIAM H. MALLINSON and JOSEPH H. WARE, Inspectors of a special election held at Archer Hall at Allendale, in the Township of Orvil, in the County of Bergen, on Thursday the 8th day of November, 1894, by virtue of the provisions of an act of the legislature of this State, entitled "An Act for the formation of Borough Governments," approved April 5th, 1878, and the acts supplemental thereto, pursuant to an order of James M. Van Valen, Judge of the Court of Common Pleas of said County, dated October 16th, 1894, a true copy whereof is hereto annexed, do hereby certify that copies of said order were set up and published as required by said act, to which was annexed a statement of the day and place when and where said original order was filed, and due notice of the time and place of said election was given according to law, all of which appears by affidavits hereto annexed, and that said election was held this day at the place designated in said order and conducted by us; we having first taken and subscribed an oath honestly and impartially to hold and conduct said election, and the ballots cast at said election having been by us canvassed, we hereby certify that the following is a true statement of the result of said elec-

On November 8, 1894, qualified residents of Franklin, Hohokus, and Orvil Townships voted 100 to 11 in favor of incorporating almost four square miles as the Mayor and Council of the Borough of Allendale. On November 10, 1894, Allendale was officially incorporated. On April 2, 1903, the council voted to change the official name to the Borough of Allendale. (Courtesy of Bergen County Clerk's Office.)

tion. The whole number of ballots was *one hundred & eleven*
of which *one hundred* votes were for incorporation and
eleven votes were cast against incorporation, giving a ma-
jority of *eighty nine* votes for incorporation.

Dated November 8th, 1894. *Alfred E. Loree* Clerk.

William H. Mallinson, :
 : Inspectors.
Joseph H. Hare :
 :

At the new borough's first election on December 4, 1894, Peter D. Rapelje was elected Allendale's first mayor along with council members Walter Dewsnap, E.E. Burtis, H.O. Doty, George W. Hatch, Charles Parigot, and C.A. Quackenbush. The first meeting of the mayor and council was held on December 18, 1894, in the parlor of Councilman Dewsnap's home. (Courtesy of Bergen County Clerk's Office.)

Oliver Hazard Perry Archer is best known as the namesake for Allendale's Archer United Methodist Church, located today at the corner of Franklin Turnpike and East Allendale Avenue. Archer owned the first baggage express delivery business on the Hudson River Railroad and later became vice president of the Erie Railroad. Retiring in 1873, his family became regular summer visitors to Allendale, eventually buying property along Franklin Turnpike and building a home there. Given the long Sunday trip to the nearest church, in 1876 Archer funded the building of a new church, in honor of his father. He and his wife, Mary, eventually donated the church and land, along with Archer Hall (and the parsonage), to the trustees of the church. The current Guardian Angel Church stands on property previously owned by the Archer family.

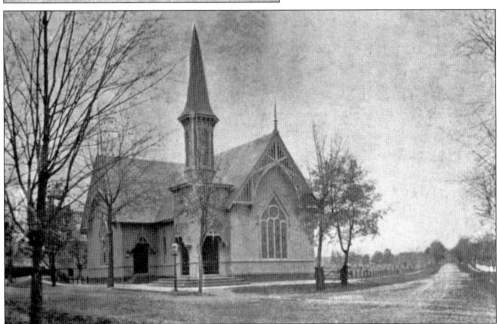

On November 8, 1894, qualified residents of Orvil, Hohokus, and Franklin Townships voted 100 to 11 in favor of incorporating as the Mayor and Council of the Borough of Allendale, effective November 10, 1894. The voting took place at Archer Memorial Church on the corner of Franklin Turnpike and East Allendale Avenue. This photograph of the church appeared in the November 5, 1894, edition of the *Souvenir*, a publication of Archer Memorial Church.

Two

ALLENDALE COMMUNITY

From Allendale's earliest days, residents have worked together to support worthwhile causes and to pay tribute to community accomplishments and sacrifices. During happy and healthy times, events such as Allendale Festival Day, the Holiday Walk, and the Fourth of July fireworks at Crestwood Lake are enjoyed. On solemn occasions, neighbors gather at Memorial Park in silence to remember those who have given so much. While voices are sometimes raised over plans for new housing developments, families and friends can always depend on Memorial Day parades, county fairs, and the Holiday Observers events at Recreation Park to bring the community together. Allendale has always been best described by a single word—community.

In 1887, then part of Orvil Township, Allendale residents created the Village Improvement Association (VIA) to advocate for modern improvements. With A.L. Zabriskie as its president, the VIA helped establish better roads and install sidewalks and streetlights. It was the VIA that brought the area's first public library to life in December 1900. Soon after Allendale incorporated, the VIA disbanded.

In the early 1900s, the first parks were Recreation Park and Memorial Park. Swimming holes and clubs were always popular. They included Mallinson Pond, the municipal pool, Lake San Jacinto, Brookside Park Swim Club, and Crestwood Lake. At its July 9, 1914, meeting, the borough council approved payments to prepare for the opening of Recreation Park, including $295.90 for excavating the swimming pool and creating baseball diamonds, $31.81 for carpentry, and $83.89 for lumber. For many years, Recreation Park was the center of borough festivities, hosting the municipal pool, baseball fields, and the Holiday Observers fireworks. Many of these activities moved to Crestwood Lake after the borough purchased the property in 1971.

During the early part of the 20th century, residents and business owners came together to form organizations to improve Allendale. In 1914, former VIA members established the Board of Trade, which was dedicated to informing and improving Allendale. In 1918, the board began a monthly newsletter that listed borough services, organizations, and local happenings. Listed organizations included the Allendale Players, Allendale Red Cross, Council on Home Defense, Boy Scouts, Allendale Fire Department, Home Guard, Library Association, Republican Club, Rod and Gun Club, Women's Patriotic League, and the Woman Christian Temperance Union. On January 3, 1919, at the request of the Board of Trade, a new women's organization was formed to improve conditions in the borough. This new group, known as the Allendale Community Club, was the seedling for future women's organizations, including today's Allendale Woman's Club.

Located at the southwestern corner of Recreation Park, the first municipal pool opened in 1915. The pool, the first municipally owned one in the county, was open to residents without

registration regulations. Its layout followed the natural contour of a lake, about 250 feet long and 150 wide at its largest part. Given design problems and the presence of bacteria, by 1940 the pool was considered a health nuisance and closed. As residents were determined to have a public swimming hole, a pool committee was formed in 1946, and in June 1949, Allendale's new and improved municipal pool was opened. The new pool had everything—sandy beaches, a diving board, floats, and lifeguards. The pool was damaged during a hurricane in 1971 and closed, about the same time the borough had agreed to purchase Crestwood Lake.

During the 1960s, residential and commercial developments were replacing remaining farmland and estates. Residents worked together to preserve the remaining open space and to save historic homes. Successful preservation efforts included Crestwood Park, the Celery Farm, Orchard Commons Park, and the Fell House.

In 1927, property owners Christopher J. Smith and Stephen T. Van Houten wanted to convert the area surrounding Mallinson's Pond into a lakeside real estate development. Given the impact of the Depression, they decided to open a swimming club, known as Crestwood Lake. It was a huge success. On August 12, 1971, the council approved Ordinance No. 374 to raise the funds to buy Crestwood for $1 million. The property would be used for recreation and would be considered as a site for various municipal buildings. September 11, 1971, was Crestwood Day, which included the dedication of the newly owned lake and swim club. On September 11, 2004, three years to the day of the September 11, 2001, tragedy, hundreds of families, friends, and neighbors gathered at Crestwood Park to attend the unveiling of a black granite monument in memory of the event. The monument included a bronze eagle, its wings outstretched, and a draped American flag.

In 1945, the parents and students of Brookside School created a community-wide project to document the history of Allendale.

In the 1970s, Mayor Ed Fitzpatrick began an effort for the borough to preserve the open space bordered by Franklin Turnpike and Cottage Place. The McBride family, who had owned the property since World War II, sold it to the New Jersey Conservation Federation, which sold it to Allendale in 1981. Additional acreage was purchased in later years, and Stiles Thomas was appointed by the council to the newly created post of marsh warden to oversee the 107-acre nature sanctuary, known today as the Celery Farm.

Allendale purchased the three-acre property at the corner of Franklin Turnpike and West Orchard Street, about to be developed into 24 townhomes, in 2007. With 2 1/2 acres preserved for a park later named Orchard Commons Park, the remaining property was allocated for six small homes built by Bergen County's United Way for developmentally disabled residents.

Allendale has always loved celebration, parades, and fundraisers. In 1919, to welcome back soldiers who served during the Great War, a parade and party were held. In 1964, communities across New Jersey celebrated the state's tercentenary (300th anniversary). On June 2 of that year, Allendale held a parade that included 17 fire departments, floats, and marchers from many local organizations. Allendale helped celebrate the nation's bicentennial with a parade in 1974, and then, on July 4, 1976, a 35-panel quilt created by local residents was presented to the borough. In 1994, the borough celebrated its centennial with a summer filled with activities. On June 18, 1994, the centennial mural, painted on the exterior wall of 87 West Allendale Avenue, was dedicated.

On Saturday, June 7, 2020, at Crestwood Lake, the communities of Allendale, Upper Saddle River, Hohokus, and Saddle River came together for the Race Visibility March to peacefully advocate for racial sensitivity in local neighborhoods.

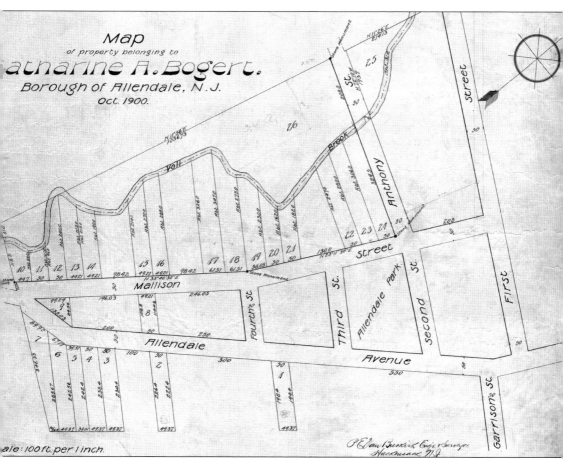

This October 1900 map of the property belonging to Catharine A. Bogert may be the earliest local street map created after Allendale was incorporated as a borough in November 1894. A close inspection reveals how many streets and properties have been changed or renamed since then. Mallison Street, probably a misspelling of Mallinson Street, now continues north behind the firehouse toward West Allendale Avenue. Allendale Avenue has been renamed Park Avenue. Allendale Park is now Memorial Park. Garrison Street is now West Orchard Street. Second Street and Anthony Street have been joined and renamed Brookside Avenue. Voll Brook is now Ramsey Brook. First Street, as it headed west, was under consideration to be joined with Hillside Avenue. Catharine A. Bogert (also spelled Bogart) of Saddle River, New Jersey, was the surviving spouse of John Augustus Bogert, who passed only a month before this map was created. Their daughter Edith Anna, a teacher in Hohokus and Upper Saddle River, would become the namesake of the Edith A. Bogert Elementary School in Upper Saddle River.

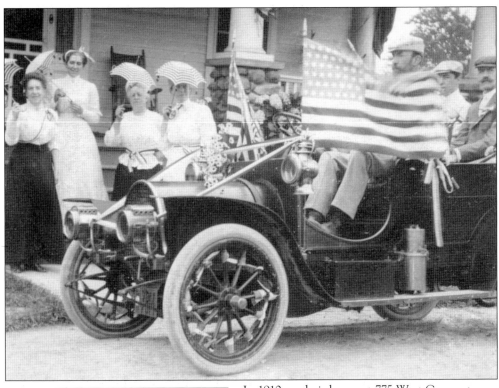

**Allendale
George Washington
Bicentennial Celebration**

Presented by

The Holiday Observers
AND ALL ORGANIZATIONS AND CLUBS OF ALLENDALE

MONDAY EVENING FEBRUARY 22nd, 1932

AT THE

ALLENDALE PUBLIC SCHOOL

8:30 P. M.

In 1910, at their home at 775 West Crescent Avenue, George and Harriett Potter host a Fourth of July gathering. With a spark of national pride as the world war ended, George Potter and neighbors pooled their fireworks to celebrate the Fourth of July. Beginning with 12 members in 1919, the group organized, and by 1923, the mayor appointed them to conduct the annual Independence Day celebration. A few years later, this group became known as the Holiday Observers. On February 22, 1932, the Holiday Observers led a celebration of the life of America's first president, George Washington. Held on the 200th anniversary of President Washington's birth, the event was a pageant in 12 episodes performed at the Allendale Public School. School principal Willard Alling was the officiating Holiday Observers president and pageant chairman. Mrs. Frederick Gordon, assisted by Edward Higgins, directed the presentation, with narration by John Wenzel, music direction by Mrs. George Feldman, and minuet coaching by Mrs. Kenneth V. Fisher. (Both, AHS.)

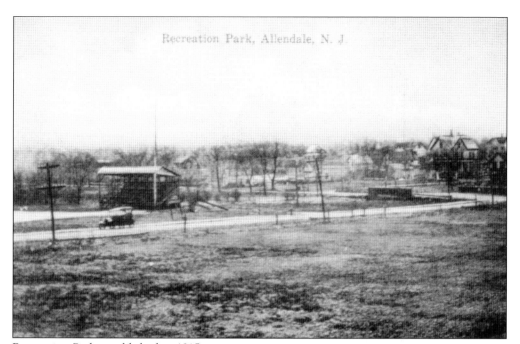

Recreation Park, Allendale, N. J.

Recreation Park, established in 1915, is located along the intersection of West Allendale Avenue and West Crescent Avenue. Over the Labor Day weekend, September 4–6, 1915, Allendale celebrated its 21st anniversary as a borough at the park. Called the Allendale Coming of Age Festival, five community groups collaborated to put together a weekend of events. The park soon added a grandstand, but by 1934, the grandstand was considered unsafe and ordered torn down. In 1935, a new grandstand was erected under the supervision of James E. Webb and Harry Pickney. Valentine Christian was the engineer in charge. After the First World War, with interest in Independence Day celebrations and with the formation of the Holiday Observers, Recreation Park became the location of the annual fireworks display. In recent years, to accommodate larger crowds, the fireworks event has moved to Crestwood Park.

PRICE FIVE CENTS.

OFFICIAL PROGRAM

OF THE ALLENDALE COMING-OF-AGE FESTIVAL (21st Birthday of Borough) AT ALLENDALE RECREATION PARK SEPTEMBER 4, 5 AND 6, 1915

Our Slogan: Allendale— It's a good place to live."

PRESS OF THE RAMSEY JOURNAL

Allendale, New Jersey

DEDICATION

OF

Soldiers and Sailors Monument

Memorial Day, May Thirtieth

Nineteen hundred twenty-five

AT

MEMORIAL PARK

"Of the People—by the People—for the People"

ABRAHAM LINCOLN

CEREMONIES

"STAR SPANGLED BANNER"
> By School Children and Choristers of Churches

INVOCATION Reverend Karl E. Warmeling, Church of Epiphany

ADDRESS Mayor William F Kornhoff

UNVEILING OF MEMORIAL MONUMENT

FLORAL TRIBUTES

"AMERICA" By School Children and Public

DEDICATION A. Eugene Pattison
> Commander Dept. of N. J American Legion

ADDRESS Reverend C. S. Woodruff, D. D., M. E. Church

ADDRESS Thomas T Haldane
> Commander Allendale Post American Legion

BENEDICTION Reverend P F. Pindar,
> Rector St. Lukes R. C. Church

Auspices of "THE HOLIDAY OBSERVERS of ALLENDALE"

Located at the corner of Park Avenue and Brookside Avenue, the Soldiers and Sailors Monument at Memorial Park was dedicated on Memorial Day, May 30, 1925, in memory of those from Allendale who served and sacrificed in the military. William Copeland of Suffern was awarded the contract by the Allendale Borough Council to place the stone memorial. The Holiday Observers coordinated the event. (AHS.)

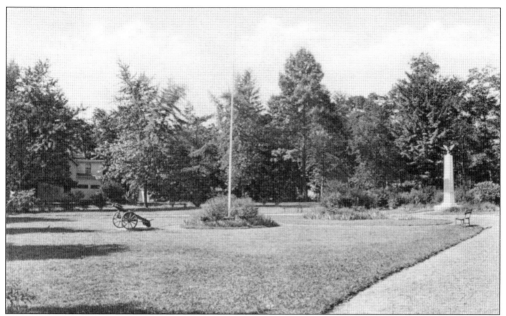

The Allendale Memorial Committee met in October 1919 to decide on a design for the monument dedicated to the memory of the Allendale sailors and soldiers who fell in the Great War. The above photograph of the monument, taken in the late 1920s, includes the first plaque honoring those lost in World War I. During the 1940s, a second world war sent Allendale's sons and daughters to battle. Dedicated during Memorial Day services on May 26, 1947, a second plaque that included the names of Allendale men who lost their lives during World War II was added to the monument. At the dedication, American Legion Post No. 204 commander Lawrence Scafuro made the opening address, and Rev. Herbert A. Sawyer delivered the invocation. Allendale mayor Frederick J. Burnett and assemblyman William Widnall were guest speakers. (Above, AHS; below, courtesy of Ed and Ethel Tellefsen.)

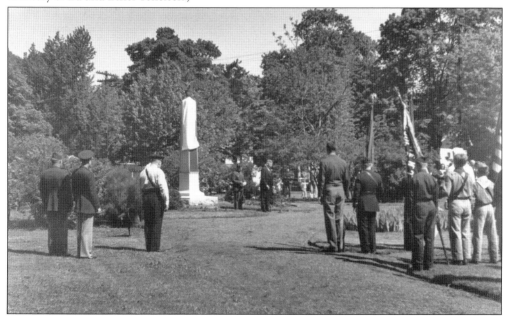

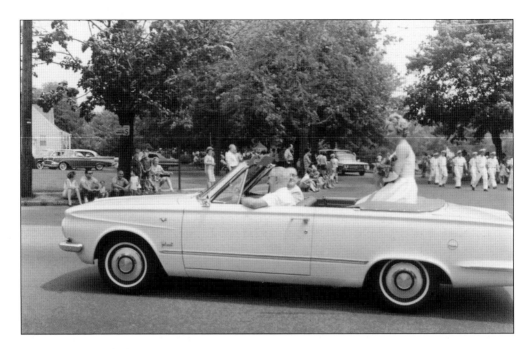

On June 27, 1964, Allendale celebrated the state of New Jersey's 300th anniversary with a big celebration and parade. Dorothy Farnan was named tercentenary queen after being interviewed by judges and providing an autobiography and essays. She was crowned on April 3 after a hootenanny at Brookside School. In the front passenger seat is the event chairman, former mayor Albert O. Scafuro. Below, in the early years of the fire department, Allendale firefighters would participate in nearby parades dressed as the Silk Stocking Boys, in white shirt and pants, a bow tie, and a straw hat. At the tercentenary parade, firefighters pull a hose cart from yesteryear, reenacting the old-style parade attire. (Both, AHS.)

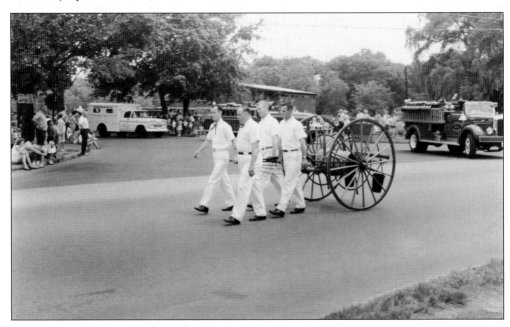

At the tercentenary parade, numerous floats participated, with Boy Scout Troop 59 capturing the first prize for the most spectacular float and second and third prizes going to the chamber of commerce and the Calvary Church. The floats of the Brownies and Girl Scouts and that of the Republican Club received honorable mention. Below, Ina M. Hamilton, chair of the history committee of the Allendale New Jersey Tercentenary Committee, presents Lee Memorial librarian Hilda Sprague with a copy of the 1964 tercentenary book *A History of Allendale*. Hilda Sprague became the library's first paid librarian in 1953. (Both, AHS.)

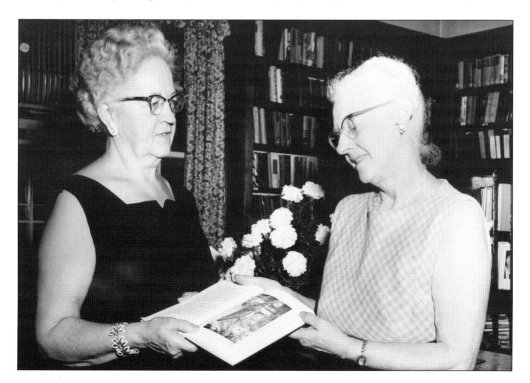

As part of Allendale's 1964 New Jersey tercentenary event, contests were held among Brookside School students for best Allendale seal and flag designs. The Allendale tercentenary seal winner was student Robert Lane. His drawing, reproduced here from the 1971 Holiday Observers event program, includes the year of the borough's incorporation, 1894, and the dogwood flower, the official flower of Allendale. Lane's drawing first appeared publicly on the cover of the 1964 commemorative book *A History of Allendale*, produced by the Allendale New Jersey Tercentenary Committee. In 1960, at the recommendation of the Allendale Garden Club, the dogwood was approved by the council as the borough flower.

During the tercentenary celebration, Mayor Robert Newman gave out awards to the design contest winners. Don Langevoort won the award for best borough flag design. The contest for best borough seal was won by student Maureen Murray. On January 6, 1965, the borough council unanimously approved Resolution No. 1, which adopted Murray's winning design as the official seal of the Borough of Allendale. The Allendale police adopted the seal, making it part of their patches. This version of the seal was included as the center panel in the bicentennial quilt and was reproduced in a larger version that sat behind the mayor's chair at borough hall.

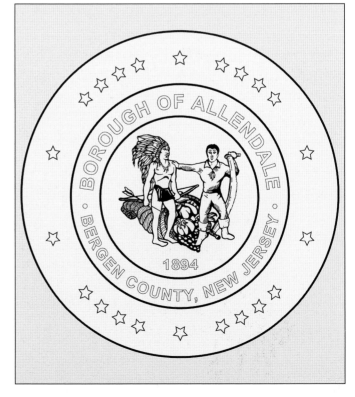

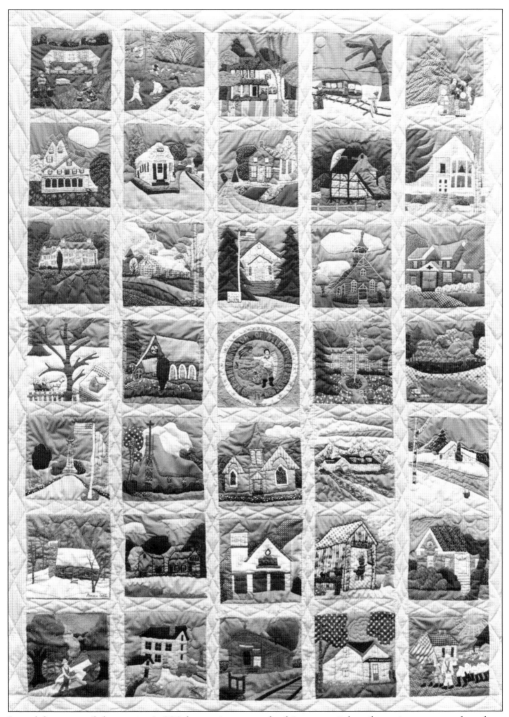

In celebration of the nation's 200th anniversary, the bicentennial quilt project was undertaken by the Junior Woman's Club of Allendale. The beautiful quilt pictured here was the result. It was presented as a gift to the Borough of Allendale on July 4, 1976.

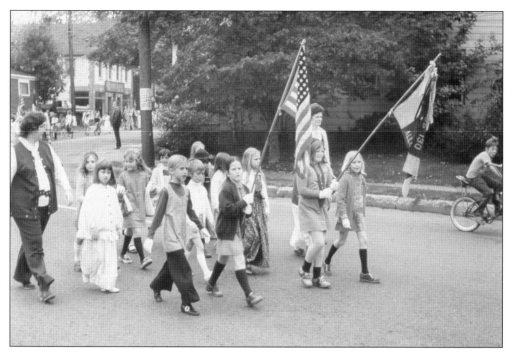

On October 12, 1974, Allendale celebrated the borough's 80th anniversary with a parade and Old Fashioned Country Fair at Crestwood Park. The day began with a flag raising at borough hall, followed by a parade and opening ceremony at Crestwood Park. The day was highlighted by the presentation of the bicentennial flag by Congressman William Widnall to borough officials. (Both, AHS.)

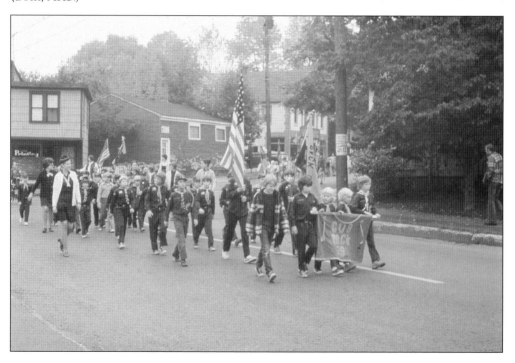

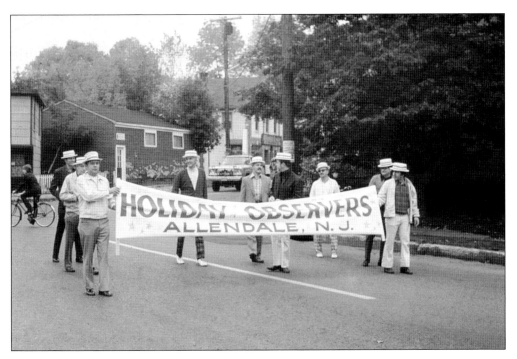

Over 4,000 borough residents spent an enjoyable Saturday afternoon watching the 80th anniversary parade and enjoying events at Crestwood Park, where a county fair sponsored by the Junior Woman's Club was held. Twenty-five local organizations and residents sponsored booths, offering a wide variety of games, food, and entertainment. Profits were distributed among local civic groups. (Both, AHS.)

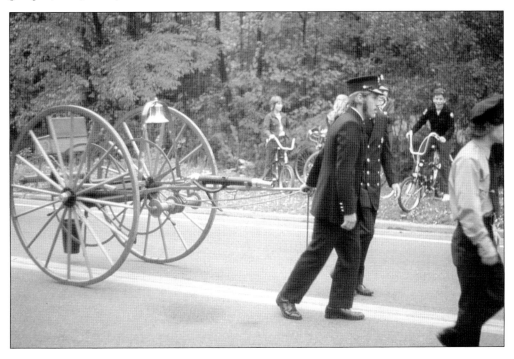

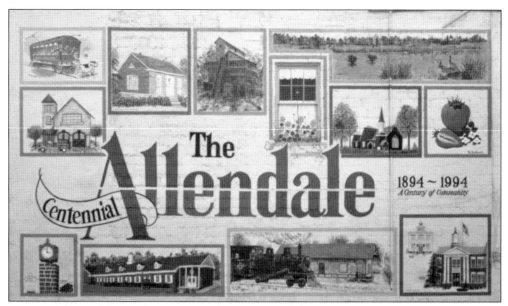

1894 ~ 1994
A Century of Community

In 1994, Allendale celebrated its 100th anniversary as a borough with a summer-long series of special events. The centennial mural, located on the wall of 87 West Allendale Avenue, was dedicated on June 18, 1994, officiated by Stiles Thomas, concept creator and project supervisor. George Takayama was the designer and project director. The mural, which depicts the history of Allendale, is made up of 12 panels arranged around the centennial logo developed by Frank Vitale.

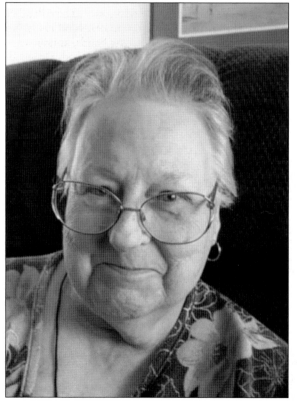

At the dedication of the centennial mural, Patricia "Patti" Webb Wardell, pictured at left, discussed the history of Allendale. Along with 69 charter members, Wardell was instrumental in forming the Allendale Historical Society in 1974. For over 20 years, she edited and contributed to *Allendale History and Heritage*, the society's newsletter. Her history-making achievement was writing the book *Allendale: Background of a Borough*, which details the historic events and families of Allendale. Wardell created numerous writings that detailed the historic buildings of Allendale and in 2013 was recognized with a mayoral proclamation establishing her as historian emerita of the borough of Allendale.

On September 9, 1994, the borough's centennial celebration included a concert led by Allendale bandleader Rod Ruth entertaining residents with the big band sound of the 1930s and 1940s. On September 24, 1994, the borough hosted a parade that included marching bands, antique cars, beautiful horses, and an old-fashioned calliope. Later that day, the Ohio Muffins and Lady Diamonds challenged Allendale men and women to an 1860s–style baseball game. A commemorative booklet, *The Allendale Centennial: A Century of Community*, was published and detailed the history of Allendale's first 100 years. (Both, courtesy of Gloria and Rod Ruth.)

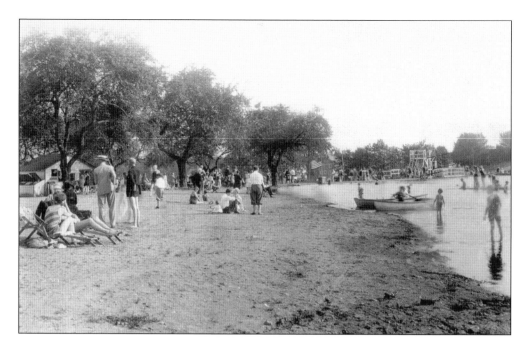

Above, summer sunbathers and swimmers are enjoying Crestwood Lake around 1928. In the 1920s, the owners wanted to develop the Mallinson pond property into a lakeside housing development. With the arrival of the Depression, property owners Christopher Smith and Stephen Van Houten decided to convert the lake and surrounding area into a swim club, which became highly successful. With land prices rising during the 1960s, the owners, the Van Houten family, considered development options. After much community discussion and debate, the Borough of Allendale stepped forward and purchased the property for $1 million in 1971. (Both, JG.)

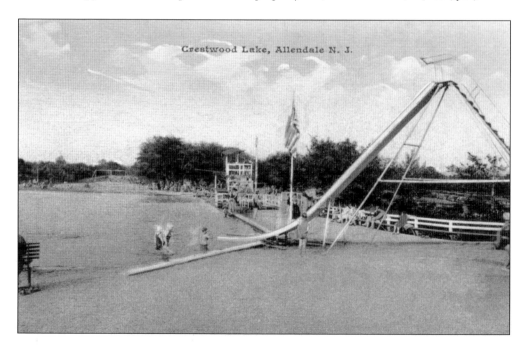

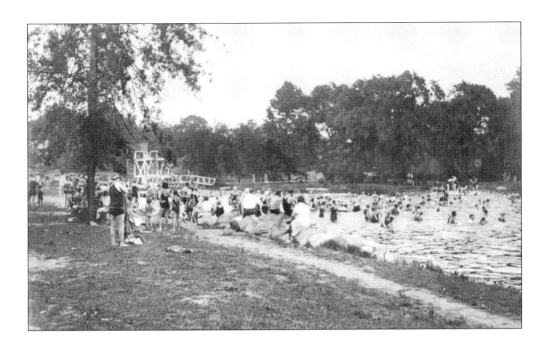

Above, bathers enjoy Lake San Jacinto on a beautiful summer day. B.F. Hutches purchased property near Brookside and West Crescent Avenues and named it San Jacinto Lake after his home state of Texas. In the winter, he sold ice, and in the summer, he welcomed swimmers to the lake. In the 1940s, with the decline of the municipal pool, a swimming hole was needed. The Newton family established the members-only San Jacinto Swim Club in the early 1950s. The property was later sold to developers who created San Jacinto Estates. (Both, JG.)

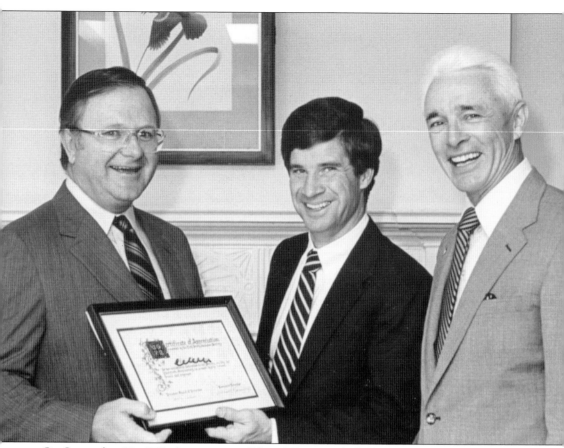

On September 30, 1983, former mayor Edward Fitzpatrick (left) and Allendale resident Stiles Thomas (right) accept the Conservationist of the Year Award from Thomas G. Gilmore, executive director of the New Jersey Audubon Society, for their leadership in preserving the Celery Farm. The story of the Celery Farm began in 1866 with John Zabriskie of Hohokus purchasing the Wolf Swamp (Celery Farm area) for use as a peat farm. Henry J. Appert purchased the property in 1888 and renamed it the Allendale Produce Gardens. In 1915, Arthur Appert bought out his father's interest in the venture. The 100-plus acres were the basis of a flourishing enterprise that sent lettuce, onions, and celery (with the brand names Triple A and King Arthur) to Philadelphia, New York, Paterson, and Boston and to the Campbell Soup Company in Camden. In 1943, Appert retired, selling the business to McBride Inc. of Paterson. Beginning in 1977, Mayor Fitzpatrick led the effort to purchase the Celery Farm from the McBride family. He obtained the services of the New Jersey Conservation Foundation (NJCF), a nonprofit organization, who purchased the property in 1979 for $170,000. The NJCF held it as the borough applied for Green Acre funds. In 1981, the NJCF sold the 60-acre Celery Farm wildlife sanctuary to Allendale. Since then, an additional 47 acres have been added. In 2003, Allendale honored Stiles Thomas for his dedication and efforts toward preserving and maintaining the Celery Farm Natural Area with a new welcoming center and a plaque, located at the entry to the sanctuary. On September 13, 2008, Allendale celebrated Thomas's 25 years as marsh warden with "Stiles Thomas Day." On October 27, 2013, in recognition of her longtime efforts to preserve a 20-acre parcel known as the Allendale Wetlands, Lillian Thomas, Stiles's spouse, was recognized with a mayoral proclamation and subsequently with a plaque near Yeomans Lane. The Allendale Wetlands were renamed the Lillian Thomas Natural Area. (Courtesy of Susan Fitzpatrick Anicito.)

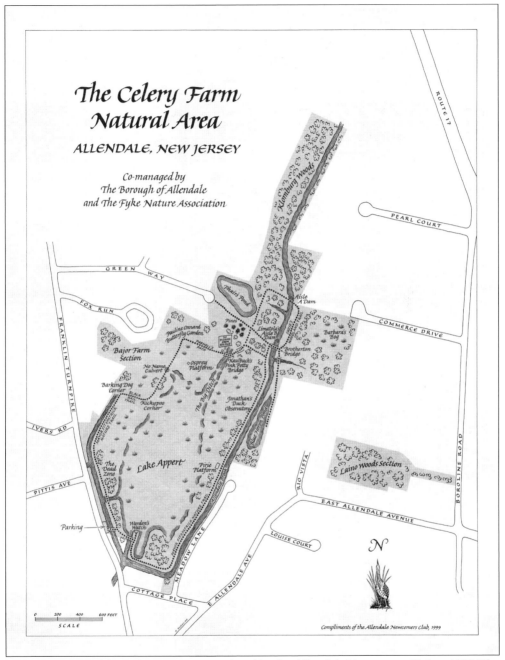

The Celery Farm
Natural Area

ALLENDALE, NEW JERSEY

Co-managed by
The Borough of Allendale
and The Fyke Nature Association

SCALE
0 200 400 600 FEET

Compliments of the Allendale Newcomers Club, 1999

This illustration of the Celery Farm was produced by the Allendale Newcomers Club in 1999. The Fyke Nature Association, a volunteer organization dedicated to conservation and environmental protection, comanages the Celery Farm with the Borough of Allendale. At its 40th anniversary dinner, the association honored former mayor Edward Fitzpatrick for his efforts to preserve the Celery Farm. (Courtesy of Susan Fitzpatrick Anicito.)

In the 1920s, Mayor Albert L. Zabriskie helped make the municipal pool the recreational centerpiece of Allendale. The swimming pool followed the natural contour of a lake, about 250 feet long and 150 wide at its largest part. Given design problems and the presence of bacteria, the pool was closed in 1940. As residents were determined to have a public swimming hole, a pool committee was formed in 1946, and in June 1949, Allendale's new municipal pool was opened.

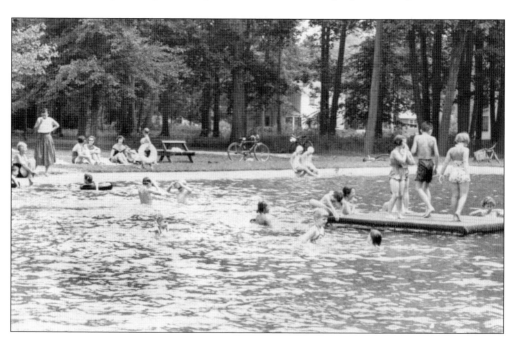

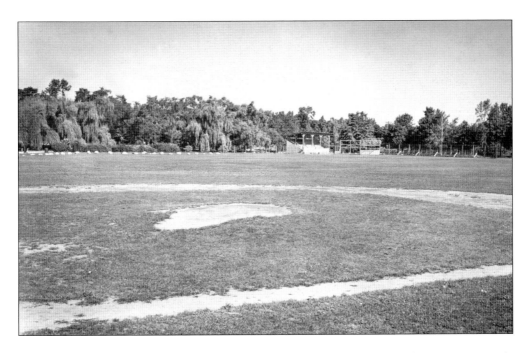

In the c. 1950 photograph above, from home plate of the southeastern ball field at Recreation Park, is the grandstand and opposite ball field near the corner of West Crescent and West Allendale Avenues. Given the efforts of the Allendale Sports Association and the Allendale Recreation Commission, Allendale's ball fields are now state of the art. In the photograph below, looking east from West Crescent Avenue, the municipal pool at Recreation Park can be seen. The building in the rear was named the Thurston Memorial Building. It included bathrooms and housed baseball and Fourth of July equipment.

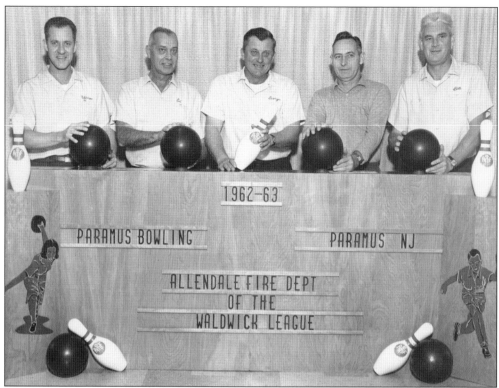

In 1963, from left to right, Warren Scherb, Ed Grosman, George Prince, Howard Uhlinger, and Bill Indoe were members of the Allendale Fire Department bowling team. Throughout the 1950s and 1960s, Tuesday night was bowling night, frequently followed by a stop at Mom Connelly's Allendale Bar and Grill. (Courtesy of Pat Indoe.)

Beginning in September 1955, the Evening Guild of the Church of the Epiphany distributed its new Allendale resident directory and telephone booklet *Here's Allendale*. The booklet contained a listing of residents with or without phones. Also included were local emergency telephone numbers in addition to hospitals, doctors, dentists, and veterinarians in the vicinity. After the alphabetical listing of residents, there is a section devoted to churches and organizations with respective contact names, meeting times, and telephone numbers. The booklet closed with a list of commercial and public sponsors. While this annual directory was a must have in every household for over 50 years, a lack of financial support and privacy concerns shuttered its publication.

For 1916–1917, the juniors of the Allendale Basketball Association included, from left to right, (first row) George Wilson, who later served as Allendale tax collector; Kenneth Fisher, who later became Allendale's mayor; and William Buhlman; (second row) Richard Ackerman, Burtis Griffiths, and Frank Drummond. (AHS.)

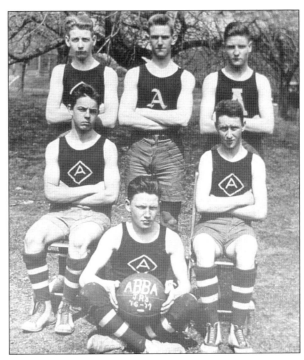

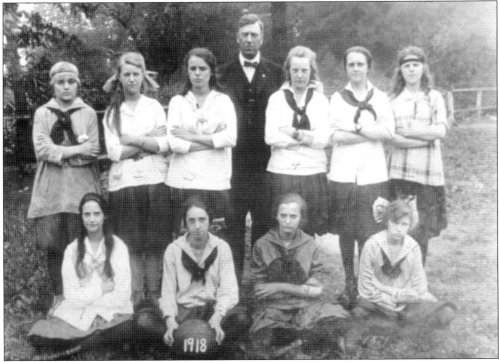

In 1918, the Allendale girls basketball team included, from left to right, (first row) Mary Robinson, Clara Nealis, Gertrude Robinson, and Rose Holman; (second row) Betty Anthony, Nancy Barnes, Mabel Knack, Willard Alling (coach/principal), Mary Hutches, Ethel Braun, and Edna "Honey" Grossman. (AHS.)

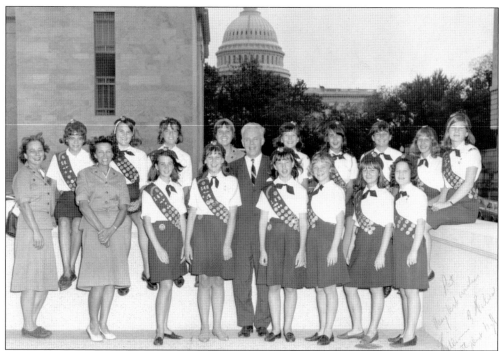

In the summer of 1965, Allendale's Girl Scout Troop 149 visited Congressman William Widnall in Washington, DC. From left to right, parents and Scouts included were (first row) Jean Norman (leader), Cecelia Indoe, Candy Grace, Laura Eichorn, Congressman William Widnall, Dorothy Briody, Kathy Keppler, Wendy Barry, and Paula Panzironi; (second row) Sue Bevalaqua, Kris Hallam, Kris Yanker, Margaret ? (exchange student), Karen VanderWerff, Karen Olbeter, Pat Indoe, Rose Kaminski, and Sandra Norman. (Courtesy of Pat Indoe.)

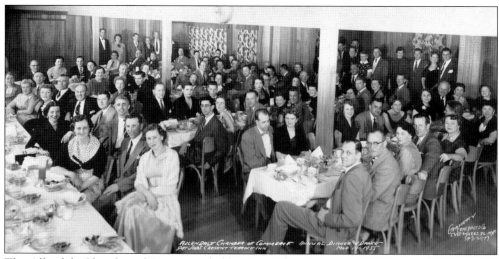

The Allendale Chamber of Commerce held its annual Dinner & Dance on March 19, 1955, at Pat Job's Crescent Terrace Inn. In recent years, the chamber has sponsored Allendale Festival Day and the Holiday Walk, bringing thousands of residents and visitors into the shopping district for food, fun, and entertainment. (Courtesy of Ted Clark.)

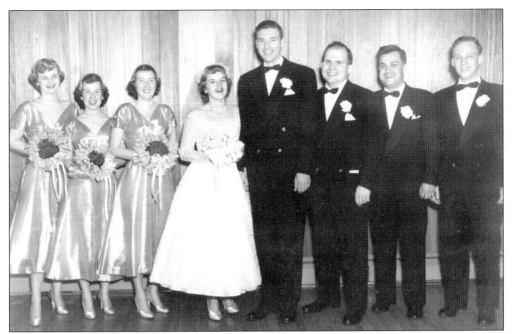

On April 18, 1953, Marilyn Wilson wed Jack Tackaberry at the Church of the Epiphany with the reception at the Crescent Terrace Inn. With the newlyweds are, from left to right, Joan Monaghan (sister of the bride), Ruth Roselander, Joan Ward, John Megnin, Stephen T. Van Houten III, and Kenneth E. Monaghan. (Courtesy of Lynn Tackaberry-Krimmert.)

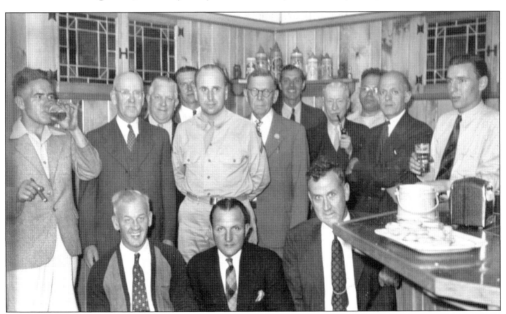

In the 1940s, friends would get together in the basement bar at 634 Franklin Turnpike. Pictured are, from left to right, (kneeling) Fred Hasenbalg, George Nelson White, and unidentified; (standing) Barney Megnin, Sam Brower, Fred Koster, Bob Wilson, Charley Bijou, William Dewsnap, Ed Grosman, W.G.Z. Critchley, Jake Kaplan, George Wehner, and Al Grossmann. (Courtesy of Janine Naphegyi Cocks.)

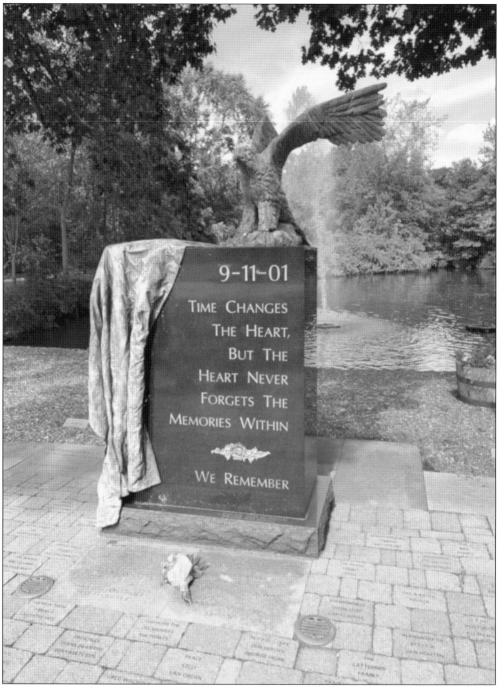

On September 11, 2004, the third anniversary of the attack on New York City's World Trade Center, the Allendale community came together to remember the victims and to dedicate a granite monument at the pond in Crestwood Park. Designed by Jason de la Bruyere and Emily Rohsler, the monument was sculpted by Mike Bertelli. This photograph was taken on September 11, 2020.

Three

MAYORS, COUNCILS, AND BOROUGH HALL

As Allendale began to organize as a borough form of government, it had no permanent municipal building for meetings, elections, or community gatherings. It had no offices for employees to work or for records to be stored in. And so, it used whatever space it could find within the borough. This often included local homes and, when gathering were large, Archer Memorial Church. Allendale's election to incorporate as a borough took place in Archer Memorial Church on November 8, 1894. Without dedicated facilities, borough records kept moving from place to place. Damp basements became popular locations for storing essential borough documents. Early Allendale tax collectors received and held real estate tax payments at their homes.

Allendale's first borough election was held on December 4, 1894, electing Peter D. Rapelje as mayor along with six council members, George Hatch, Cornelius Quackenbush, Horace O. Doty, Walter Dewsnap, Charles L. Parigot, and Edward E. Burtis. The first meeting of the mayor and council was held in Councilman Dewsnap's parlor on December 18, 1894.

In need of meeting space, the mayor called upon Councilmen Doty and Hatch to ask the president of the school board, J.B. Willard, if they could hold future meetings at the schoolhouse on Franklin Turnpike. And so, the governing of the borough of Allendale was off and running.

The following meeting, on December 27, 1894, was held at the schoolhouse, which was built in 1862 on property provided by Peter G. Powell. Occasionally, Melchionna's Hall at the corner of Park and West Allendale Avenues served as a community meeting place. The next schoolhouse, built in 1896 on Franklin Turnpike, then served the community for many years. Given its larger accommodations, which were dedicated in 1913, the new firehouse at Erie Plaza became the next long-standing meeting place.

Borough leaders were continually searching for property that could serve as a municipal complex that would include a borough hall, police headquarters, and public library. Throughout Allendale's history, several sites have been considered and rejected, including the Berdan Property (where ACME now stands) and Crestwood Lake.

After Brookside School was built in 1929, the former schoolhouse on Franklin Turnpike suffered from neglect. In the 1940s, the building was leased to American Legion Post No. 204, which later purchased the property for $1. In 1947, the schoolhouse was renamed the War Memorial Building. The American Legion spent $15,000 making various changes to the structure. The second floor

was removed to save on heating costs. The American Legion held its meetings there and leased the space to local civic groups. In early 1950, the mayor and council approved changing their meeting place from the firehouse to the War Memorial Building, citing its larger size. By 1960, the American Legion membership had dwindled to about 22, and the members were no longer able to maintain the building. As such, the ownership reverted to the board of education, which then deeded the building back to the borough. Effective September 1960, Mayor Newman and the borough council took control of the building, paying $1 for the property and agreeing to maintain the $700 monthly costs.

On June 24, 1961, the borough dedicated its first permanent municipal building at 290 Franklin Turnpike. The building planned to house offices for the tax collector, police department, Board of Public Works, municipal court, violation bureau, Board of Health, Board of Assessment, and borough clerk. In addition, the Allendale Borough Council and other civic groups would be able to hold meetings there.

Nonetheless, the need for space continued. In 1971, police headquarters moved to a rented residential home at 59 Cottage Place. The public library building, located at the corner of Franklin Turnpike and West Allendale Avenue since 1926, was in decline.

In 1978, as the Church of the Epiphany could no longer afford to maintain its new church at 500 West Crescent Avenue, it sold the property and building to the borough, making the church the municipality's new borough hall along with a new home for the Lee Memorial Library.

That year, the police department moved into the previous municipal building at 290 Franklin Turnpike. In 2005, with 110 years of service to the community, the borough's police headquarters, having served as the third schoolhouse and former municipal building, was razed. On the same site, a new state-of-the-art police headquarters was dedicated the following year.

The mayoral term of office was originally two years, but by a vote of the council in 1970, it was expanded to four. Since the first Borough of Allendale election in 1894, here are Allendale's mayors, their term in office, and party affiliation (when available): Peter D. Rapelje, December 4, 1894–February 25, 1897; George Cook, March 15, 1897–1900; Walter Dewsnap, 1901–1905; Charles S. Roswell, 1906–1909; Walter Dewsnap, 1910–1911; John W. Winter, 1912–1913; Gustave Nadler, 1914–1918; Orival O. Clark, 1919–1920; Albert L. Zabriskie, 1921–1924; William F. Kornhoff, 1925–1926; J. Parnell Thomas, 1927–1930; Malachi E. Higgins, 1931–1934; Kenneth V. Fisher (R), 1935–1938; Louis A. Keidel (D), 1939–1942; Lyman Ceely (I), 1943–1944; J. George Christopher (I), 1945–1946; Frederick J. Burnett (R), 1947–1950; Lester R. Johnson (R), 1951–1952; John L. Tucker (I), 1953–1956; Albert O. Scafuro (R), 1957–1958; George A. Dean (R), 1959; Robert I. Newman (R), 1959–1966; Joseph F. Waldorf (R), 1967–1968; Herbert Lange (R), 1969; Albert J. Merz Jr. (R), 1969–1972; Norman S. Lane (R), 1972; Robert Schenk (R), 1973–1974; Edward Fitzpatrick (R), 1975–1982; William Simpson (R), 1983–1987; Clarence Shaw (R), 1987–1990; Albert H. Klomburg (R), 1991–2006; Vince Barra (R), 2007–2014; Elizabeth White (R), 2015–2018; and Ari Bernstein (R), 2019–incumbent.

On November 7, 1922, Martha Parkhurst was elected as Allendale's first councilwoman, serving one term.

Today, the borough is New Jersey's most popular form of government. It provides for a mayor and a six-member council, elected separately at the November general election. The mayoral term is four years, while council members serve three-year staggered terms, with two council seats up for reelection every year. The council has all executive responsibilities not specifically assigned to the mayor. As such, the borough form of government is known as the "strong council, weak mayor" form. The mayor runs the council meetings and can only vote to break a tie.

Allendale Dec 18th 1894.

A meeting of Council was held in Councilman Dewsnaps parlor on the above date with Mayor Rapelya in chair Councilmen present Burtis. Dewsnap. Doty, Hatch, and Parigot

It was moved by Councilman Parigot and seconded by Dewsnap that the clerk Salary be Fifty Dollars per annum carried. Councilman Dewsnap. moved and was seconded by Burtis. that the clerk be authorized to order Eight copies of by-laws. carried

The Mayor appointed and was confirmed the following committees Commissioners of Streets and highways Councilmen Doty Dewsnap. and Burtis. Finances. Councilmen Hatch Parigot and Quackenbush, Ordinance Councilmen Dewsnap. Hatch Parigot. Lamps. Councilmen Burtis. Hatch Doty.

The mayor appointed Councilmen Doty and Hatch. to call on the President of School Board Mr J.B. Willard in Reference to holding meetings in the school house — Councilman Parigot moved and seconded by Dewsnap. that the Mayor be authorized to appoint a marshall until the next meeting of Board of Council.

Robert D. Nimmo
Clerk.

This page 1 is the first page of the minutes of the first meeting of the newly incorporated Mayor and Council of the Borough of Allendale. The meeting was held on December 18, 1894, in the parlor of Councilman Walter Dewsnap's home. The governing body and borough administration would not have a permanent home until 1961.

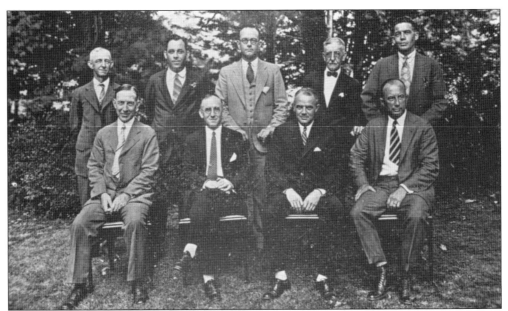

The 1929 governing body included, from left to right, (seated) council members Charles F. Smith and Robert S. McNeill, Mayor J. Parnell Thomas, and council president Frank Berdan; (standing) borough engineer Harry Doolittle Sr., council members L.A. Rudolph and David Colburn, borough clerk W.W. Pollock, and Councilman Eugene Megnin. (AHS.)

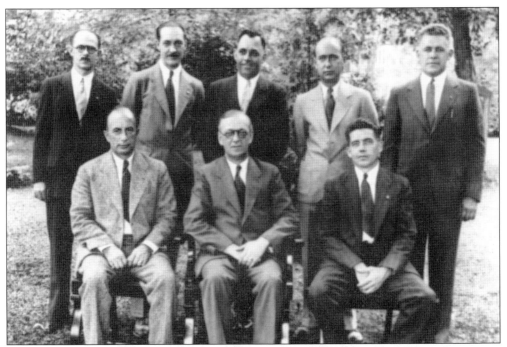

The 1931 governing body included, from left to right, (seated) Councilman Frank Berdan, Mayor Malachi E. Higgins, and Councilman Eugene E. Megnin; (standing) borough clerk Raymond P. Arlt and Councilmen C. Harry Minners, Leslie A. Rudolph, E. Kenneth Burger, and John G. Hubbard. (AHS.)

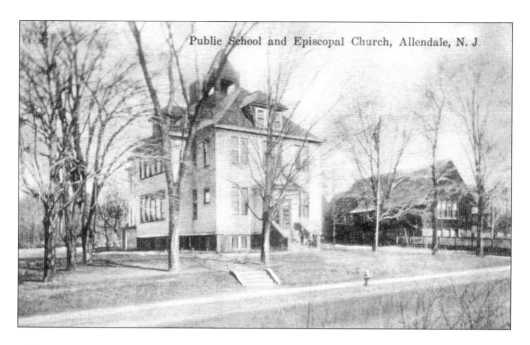

Public School and Episcopal Church, Allendale, N. J.

Allendale's third schoolhouse on Franklin Turnpike became the regular meeting place for the mayor and council. On December 1, 1935, in front of the Allendale Public School on Franklin Turnpike are, from left to right, (first row) council members John P. Doehling and Maude G. Pittis, Mayor Kenneth V. Fisher, and council member Herbert W. Flandreau; (second row) borough clerk George Wilson and council members Muried Christopher, George Alberts, and Casper J. Korndorfer. (Below, courtesy of Marilyn Wilson Tackaberry.)

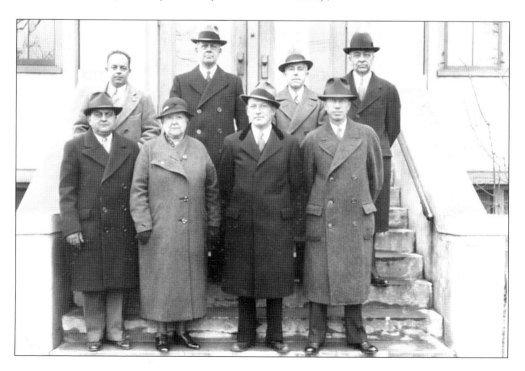

In 1947, American Legion Post No. 204 purchased the old 1896 schoolhouse on Franklin Turnpike and converted the building into its headquarters. It was named the War Memorial Building to remember those who served and sacrificed to defend the nation. To save on heating costs, the American Legion removed the second floor. The Borough of Allendale would later use the building as its headquarters. (AHS.)

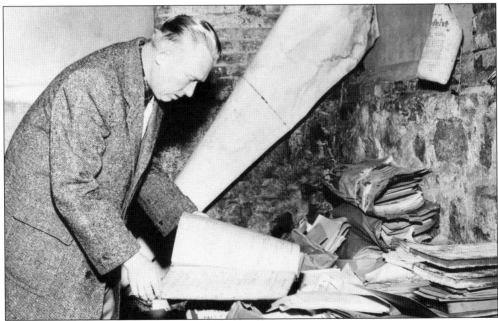

In 1959, Mayor George A. Dean Jr. inspects borough records stored for too many years in the fireproof storage room in the basement of the War Memorial Building. While they have remained free from damage by fire, dampness and mildew have been gradually destroying them. (AHS.)

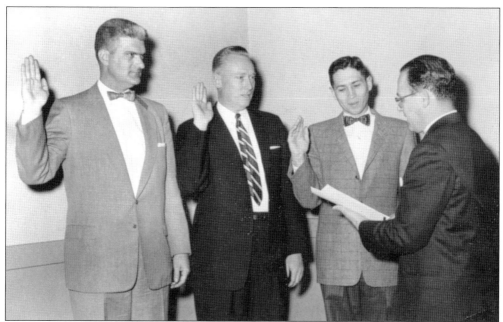

On January 3, 1959, at the annual Allendale Mayor and Council Reorganization Meeting, outgoing mayor Albert O. Scafuro administers the oath of office to his successor George A. Dean Jr., center, and two reelected councilmen, Robert I. Newman, left, and Victor J. Cotz, right. (AHS.)

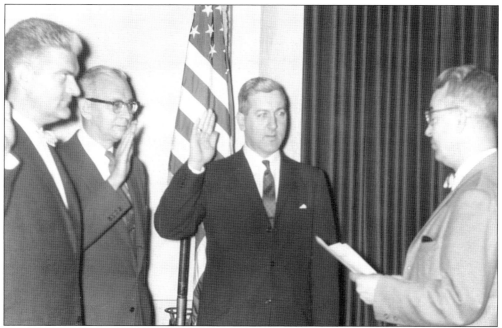

During the annual Allendale Mayor and Council Reorganization Meeting on January 1, 1961, at the firehouse at Erie Plaza, borough clerk J. Frank Rouault (far right) swears in, from left to right, Mayor Robert Newman and council members Robert Lane and John Waldorf. Lane and Waldorf will both later serve terms as mayor. (AHS.)

These photographs capture the Allendale Municipal Building when it was located at 290 Franklin Turnpike during the 1960s and 1970s. American Legion Post No. 204 took possession of the building in the late 1940s, renaming it the War Memorial Building. No longer able to maintain the structure, the American Legion returned it to the borough, and on June 24, 1961, it was dedicated as the borough's first municipal building. In attendance were council members Joseph Waldorf and John Morton, Mayor Robert Newman, master of ceremonies Russell K. Stewart, and Congressman William B. Widnall. In 1979, the building became the Allendale Police Department headquarters after the borough administration moved its operations to 500 West Crescent Avenue. (Both, AHS.)

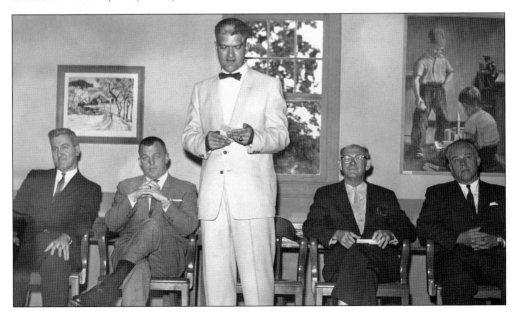

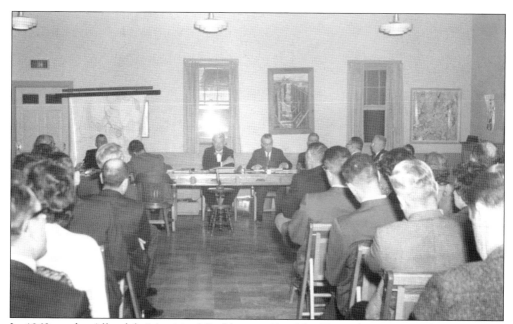

In 1963, at the Allendale Municipal Building on Franklin Turnpike, Mayor Robert Newman, sitting beneath the flash, along with the Allendale Borough Council, faced a packed audience to discuss rezoning 121 acres near Boroline Road for industrial use. After intense public criticism, a decision on the rezoning was tabled, pending additional information and discussion. (AHS.)

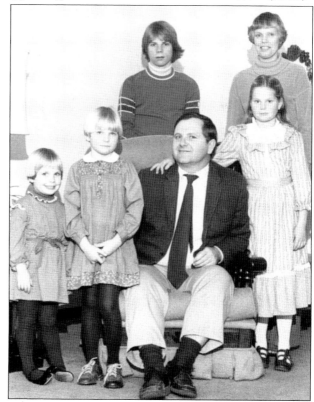

Mayor Edward N. Fitzpatrick with wife Susan and children, from left to right, Cara, Mary Beth, Tim, and Colleen are getting ready for the mayor to be sworn in for his second term in January 1979. Serving from 1975 to 1982, Mayor Fitzpatrick was instrumental in efforts to purchase and preserve the Celery Farm in 1981. He also managed Allendale's semipro baseball team for 20 years, never having a losing season. On May 12, 2001, Fitz's Press Box was dedicated at Northern Highlands Regional High School honoring him for his efforts supporting Allendale baseball at the little league, high school, and semipro levels. (Courtesy of Susan Fitzpatrick Anicito.)

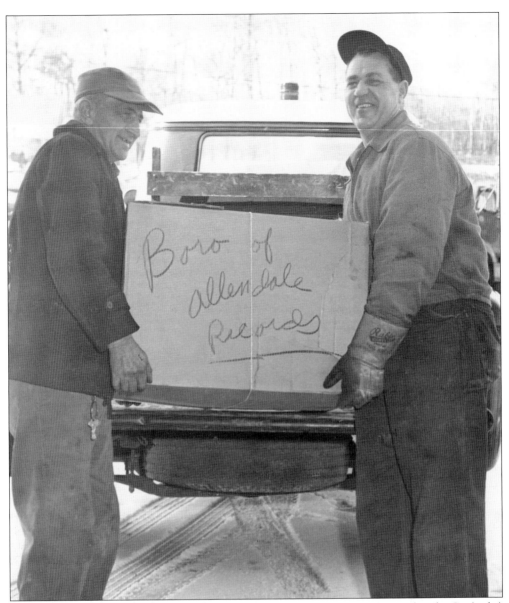

The Allendale Road Department's Al Hover (left) and Peter "Pete" Cauwenberghs Sr. (right) move borough records into the Adams storage warehouse on Route 17 in Upper Saddle River. Cauwenberghs began working for the Borough of Allendale on May 15, 1947, retiring at the end of 1984 as superintendent of the Roads, Public Buildings, and Grounds Department. After serving his country in the Navy during World War II, he later served his borough as ambulance corps captain and borough marshal. Cauwenberghs and his wife, Erma, are the parents of Gail, Peter Jr., Sue, Keith, and Rick. Their son Keith followed in his dad's footsteps, working for the Allendale Department of Public Works (DPW), retiring in 2012 as director of operations after 41 years. The Cauwenberghs will forever be remembered for their selfless contributions to Allendale with the DPW headquarters on New Street being renamed as the Cauwenberghs Building on September 28, 2012. Hover, a World War I veteran and fire department volunteer, retired from the road department in 1964. (Courtesy of Keith Cauwenberghs.)

Four

SCHOOLS AND LIBRARIES

Five public schools and one regional high school have been built in Allendale since 1826. While 19th-century historians have implied the existence of earlier buildings used for education, no specifics can be found.

Located at the northwest corner of Chestnut Street and Franklin Turnpike, the first documented schoolhouse serving Allendale, built in 1826, was known as the "little red schoolhouse." It was one story, 16 feet by 24 feet, and students sat from 9:00 a.m. to 4:00 p.m. on long backless benches. The first board of trustees included John G. Ackerman, John G. Ackerson, and Albert A. Garrison, who employed Isaac Demurest as the earliest teacher.

School No. 2 was built in 1862 on property provided by Peter G. Powell on Franklin Turnpike near the corner of East Orchard Street. This building, 25 feet by 35 feet and adorned with a belfry and blinds, was valued at about $2,000. There was a provision in the deed that the property would revert to the Powell Estate if the property was no longer used for a school. The earlier 1826 schoolhouse was moved to John Wilson's farm, where it was used to store grain.

By the 1880s, with J. Alfred Ackerman teaching, the schoolhouse was already too small. In 1896, a new two-story school was built behind the 1862 schoolhouse on Franklin Turnpike. Dedicated on December 18, 1896, this school was built by Stephen Van Blarcom for $5,500. It contained eight classrooms, teaching grades one through eight. It had separate entrances for boys and girls, perhaps befitting the morality of the times. School No. 2, sold by auction to H.J. Appert for $65, was soon moved to his Allendale Produce Gardens on Franklin Turnpike, where it was destroyed by fire in 1938.

In January 1928, residents voted two to one to purchase the Anthony property for $165,000 for a new school located near the corner of West Crescent and Brookside Avenues. This public school was dedicated on September 6, 1929. The school's first class of 1930 had 225 students with Willard Alling as its principal. While the name "Brookside School" was used as early as 1942, the 1968 graduation booklet displayed the name for the first time.

The aftermath of World War II brought new population growth, resulting in dividing the public school into two separate schools, with fourth to eighth grades remaining at Brookside School and kindergarten to third grades moving to the newest public school, Hillside Elementary School. With Aileen Wilson appointed as its first principal effective September 1967, the new Hillside School opened with 595 students. It was dedicated on October 15, 1967.

Before 1964, high school students from Allendale attended Ramsey High School, then Mahwah High School. Voters from Allendale and Upper Saddle River approved a referendum on May 24, 1963, to build a new regional high school on Hillside Avenue in Allendale. Ground-breaking

ceremonies for a new regional high school took place on May 15, 1964, on Hillside Avenue, on property owned by Peter G. Koole. The new Northern Highlands Regional High School, serving Allendale and the surrounding communities, officially opened its doors to students on Monday, September 20, 1965, and held its dedication on Sunday, March 20, 1966.

In the late 1800s, macadamized roads and reliable rail transportation brought vacationers and new homeowners to Allendale. The need for summertime activities, such as a library, became evident. The Village Improvement Association (VIA), a local civic group established in 1887, formed a library committee to create a new library. Allendale's first library was established in December 1900, located within the public school on Franklin Turnpike. Staffed by volunteers, the new library offered 600 books. Open July through August, the library was independently funded with annual membership dues, borrowing fees, and private donations. Around 1910, the library had to move to new quarters as the school needed a new cloak room. It found a new home in John Ackerman's store, located at Erie Plaza. A few years later, in 1915, the library moved across the plaza to the second floor of the firehouse. In 1919, the Braun Building, also known as the Flatiron Building, became the library's new home. With the borough now incorporated and with its own government representation, the VIA and its library committee were disbanded.

With the need for a permanent home and dedicated community support, in August 1919, members of the former VIA library committee incorporated as the Allendale Library Association. Their focus was to perpetuate the library and to look for its permanent home.

On January 11, 1923, the library committee signed an option to purchase the property owned by William H. and John A. Mallinson at the corner of Franklin Turnpike and West Allendale Avenue. In November 1923, the Allendale Library Association incorporated, and on December 28, 1923, a deed was signed transferring the property from John A. Mallinson; his wife, Mary C. Mallinson; William H. Mallinson; and his wife, Emma G. Mallinson, to the Allendale Library Association.

With William Dewsnap as the architect, construction of the new library building began in April 1926. On December 18, 1926, the new Allendale Public Library was dedicated. In 1941, William C. and Mary K. Lee donated a new wing to the library building, which was completed in November. Insufficient funding and growing demand required a need for the municipality to assume responsibility for the library. On November 4, 1952, with a referendum on the ballot, the citizens of Allendale voted 876 to 223 to have the borough take over all aspects of the library, including the building and property. On January 6, 1953, the new borough-operated library incorporated as the Trustees of the Free Public Library of the Borough of Allendale. It would now be a free public library.

On December 8, 1952, in memory of William C. Lee, the library board voted unanimously to change name of library to the Lee Memorial Library. On January 6, 1953, library trustees passed a resolution appointing Mary K. Lee honorary advisor to the board of trustees for life. In February 1953, Hilda Sprague became Allendale's first paid librarian. On March 13, 1953, at an open house, Schuyler C. Lee unveiled bronze letters over an interior library doorway that read, "The Mary K. Lee Room."

In May 1971, library volunteers met in the home of Mrs. Samuel Raber to discuss how the library could also serve as a cultural center for the community. These volunteers worked alongside library staff to ease their workload. Before adjourning their meeting, they voted to organize and call themselves "Friends of the Library." With a growing interest in new books and with the Franklin Turnpike building needing repairs, the library moved to 500 West Crescent Avenue adjacent to borough hall. After completing required modifications, the new location of the Lee Memorial Library was dedicated on May 20, 1979.

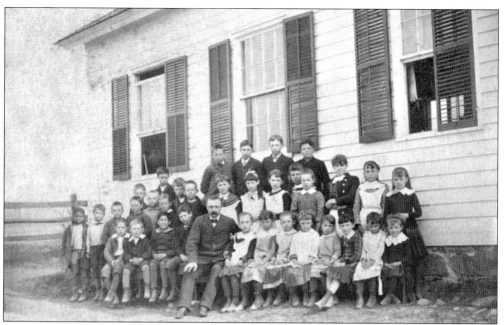

In May 1884, Allendale's second public school stood on Franklin Turnpike near East Orchard Street. The teacher was James Alfred Ackerman with students John Yeomans, Hattie Sterling, Willie Roswell, Cornelius Hopper, Robert Beckley, Eva Smith, Lizzie Ackerman, David Folly, Watts Anthony, Charley White, Roe Quackenbush, Chartre Mallinson, George Parigot, Allie Pullis, Emma Mallinson, Nellie Storm, Carrie Ackerman, Mazie Harris, Edith Roswell, and Lidie Storms.

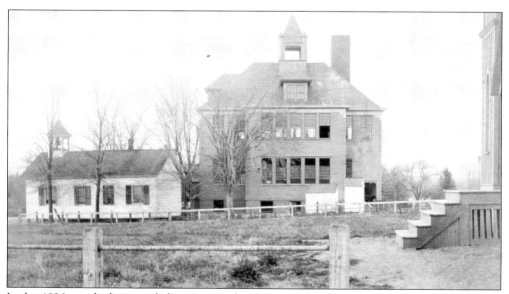

In this 1896 view looking north from East Orchard Street, Allendale's newest two-story schoolhouse is being completed. The smaller building at left is Allendale's second schoolhouse, built in 1862. The steps at right belong to the Church of the Epiphany, moved from Cottage Place in 1894.

Public Auction of Sale of old School Building and Out Houses. November 10 / 1896.

The old school House was sold sold on the agreed Conditions to Henry J. Appert for the sum of $ 65 —
the Woodhouse to Martin Quakenbush for 3 50
the Boys Closet " Charles Q . " 2 00
the Girls Closet to Martin Quakenbush " 2 50
$ 73 00

J. B. Willard acting as Auctioneer

The above snippet is from the Allendale Board of Education meeting minutes on November 10, 1896. Due to the building of a new schoolhouse in 1896, the Allendale Board of Education no longer needed the previous school building. An auction was held, and the schoolhouse and the nearby outhouses were sold. Henry J. Appert, then Allendale Board of Education district clerk, purchased the schoolhouse for $65 and moved it to his farm, where it burned down in 1938.

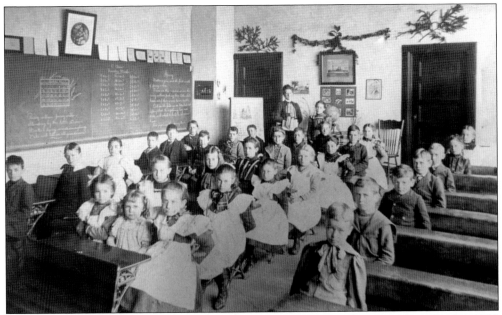

Allendale's third public school, built in 1896, had four rooms and two teachers. In this 1900 photograph, teacher Sadie Salyer heads a class of young students. That year, seven students graduated. (AHS.)

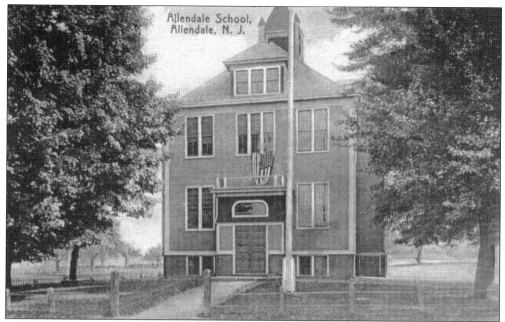

Once Allendale incorporated as a borough in 1894, its first task was to build a new public school. Its third public school, dedicated in 1896, was built on Franklin Turnpike directly behind the previous 1862 schoolhouse.

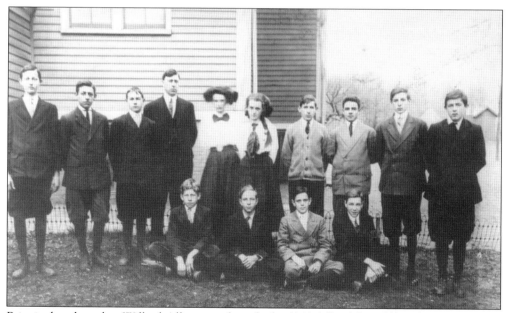

Principal and teacher Willard Alling stands with the 1910 Allendale Public School graduating class at the schoolhouse on Franklin Turnpike. Pictured above are, from left to right, (first row) James Hubbard, Oliver Asten, John Borger, and William Abbott; (second row) Arthur Kinskey, Percy Fisher, Bertram Sneden, Willard Alling, Rita Stocker, Lillian Boomer, Russell Mallinson, J. Parnell Feeney, Jack McDermott, and Herbert Winter. (AHS.)

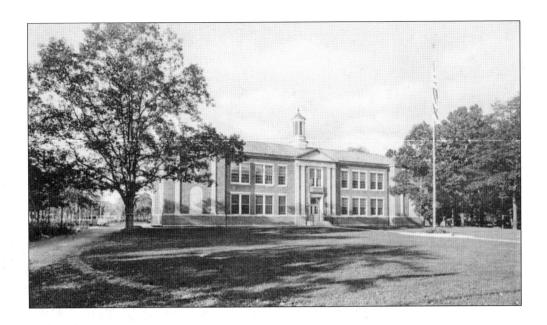

Pictured above is Allendale's fourth public school, located on Brookside Avenue. It was dedicated on September 6, 1929, and Willard Alling was the first principal. Allendale's fifth public school, Hillside Elementary School, pictured below on Hillside Avenue, was dedicated on October 15, 1967. Congressman William Widnall, representing New Jersey's Seventh Congressional District, presented a flag for the school's use to the new principal, Aileen Wilson. John Crothers, Allendale Board of Education president, received the keys to the school from architect J. Robert Gilchrist and transferred them to Henry C. Seibel, superintendent of Allendale Public Schools. Remarks were provided by Allendale mayor Joseph F. Waldorf and Henry Seibel.

The Northern Highlands Regional High School's (NHRHS) 40-acre site was purchased in September 1963 with the new two-story building projected to cost $3.65 million. The doors opened in September 1965 with John W. Mintzer as its first principal. There was no senior class in the building during the 1965–1966 school year; only freshmen, sophomores, and juniors were attending classes during that time. Thus, the first graduation ceremony did not take place until a year later in June 1967, when those juniors were seniors and became the first graduating class of NHRHS.

In 1965, the Northern Highlands crest (coat of arms) was designed by Dennis Mamchur, a graduation jewelry salesperson for Jostens. After much research, Mamchur designed the crest to symbolize the local people and land of the Northern Highlands. The coat of arms includes the following: a gold crest with a thistle, the national flower of Scotland; a gristmill representing Allendale as it was built in 1800 on the Hohokus Brook near West Crescent Avenue; a rock wall depicting the one in front of the school; the dogwood flower representing Upper Saddle River; two crossed Scottish swords pointing downwards representing peace; and the Scottish plaid tartan symbolizing the associated clan. The tartan is red and black, the school's colors. (Courtesy of Joseph Occhino.)

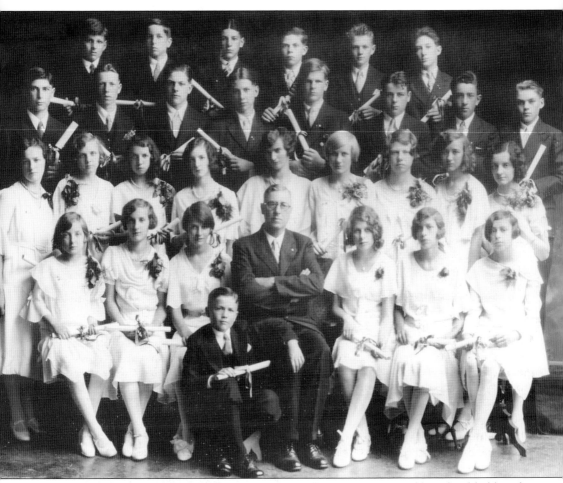

Opening its doors on Brookside Avenue in 1929, Allendale's newest public school held its first graduation in the school auditorium on Friday, June 20, 1930. The graduates are, from left to right, (first row) Edwin Kemp; (second row) Elizabeth Burger, Anna Reimer, Irene Goldman, Principal Willard Alling, Dorothy Jansen, Bessie Nuzzo, and Christina Nuzzo; (third row) Emma Cutler, Isabel Dunkel, Ruth Simpson, Leola Strong, teacher Gertrude Robinson, Doris Fields, Jeanette Schneider, Laura Dobienjski, and Jennie Lusardi; (fourth row) Raymond Roswell, Alfred Ackerson, Howard Vanderbeck, Alfred Klaschka, Alfred Fields, Edward Russell, Albert Espenship, and Lewis Thurston; (fifth row) William Phair, Ferol Vernon, Joseph Caputi, Edward Strangfeld, Robert Hill, and Robert Finley. Willard Alling served the Allendale Public Schools for 33 years as teacher and principal. Born in Wyoming, Pennsylvania, Alling was a graduate of Harvard University and received his teacher training at Pennsylvania State Normal School. After graduating from New York University Law School, he was admitted to the bar in New York and New Jersey. In addition to his principal responsibilities, Alling served eight years as Allendale borough tax collector during the term of Mayor J. Parnell Thomas, one of his students in 1910. (Courtesy of Nancy Strangfeld Cauwenberghs.)

Administrators and teachers are pictured on this page from the 1959 Brookside School class book. The graduating class was given a book of teachers and students without names. Each eighth-grade graduate had to visit with their teachers and classmates one last time to get their signatures. (Courtesy of Meredith Monaghan Ettenberg.)

In 1967, Aileen Leifert Wilson was appointed Hillside Elementary School's first principal. Dr. Wilson's teaching career began at Brookside School in the fall of 1964, where she taught sixth grade for three years. During her tenure, she also served as principal of Brookside School from 1984 to 1989. Born in Staten Island, she moved to New Jersey, graduating from Ramsey High School in 1950. Taking evening classes at Paterson State College, she graduated with a bachelor of arts in elementary education in June 1963. She returned to Paterson State to obtain her master's degree in elementary education with a major in language arts in 1966. In 1967, she attained elementary school principal certification. In 1975, after graduate studies at Columbia University, she gained superintendent certification and in 1984 received her doctorate. Serving the Allendale Public Schools for 28 years as teacher and principal, she retired on May 21, 1992. Dr. Wilson and her husband, Richard, a New Jersey state trooper, are the parents of Gregory, Gail, Sandra, Richard, John, and Catherine. (Courtesy of Sandra Wilson Thurston.)

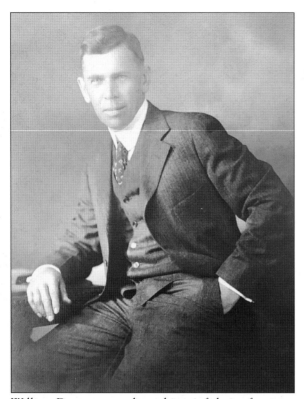

William Dewsnap was the architect of choice for many Allendale buildings, including the 1907 Church of the Epiphany parish hall on Franklin Turnpike, the 1913 Allendale firehouse, and the 1926 Allendale Public Library on Franklin Turnpike. Actively involved in the community, he served on the Allendale Board of Education. A life member, Dewsnap was first president of the new Allendale Fire Department, serving for 25 years. He drew up the plans for a new firehouse, dedicated in 1913, at no charge. He married the granddaughter of Peter G. Powell. In 1926, funds were raised to create the library's first permanent home on the corner of West Allendale Avenue and Franklin Turnpike. On March 21, 1931, H.E. Sylvester Buechner presented to the library board of trustees a framed panel on which names of all who had contributed to the building fund were inscribed. The panel was beautifully hand-lettered by his daughter Eugenia Buechner. The original hangs today at Lee Memorial Library. In 1978, as the library needed more room, it and the Allendale Borough Administration moved to new facilities at 500 West Crescent Avenue. (Above, courtesy of Warren Storms.)

The Lee family was a major financial supporter of the Allendale Public Library, with William C. Lee serving as the president of the board of trustees and Mary K. Lee becoming one of its first librarians. Inside the Allendale Public Library building on Franklin Turnpike, the Lees hold the original public library sign. The first library was established in December 1900 by the library committee of the VIA, a local group that advocated for community resources. (Both, LML.)

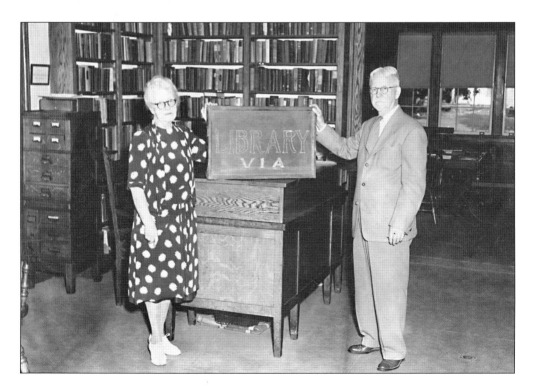

William C. and Mary K. Lee, generous supporters of the Allendale Public Library, celebrate their 50th wedding anniversary in 1950. William Lee served the library for over 31 years, first as a trustee, later as vice president and treasurer, and finally as president. Mary Lee served as librarian for more than 30 years. On June 16, 1941, the Lees presented to the board of trustees their generous offer to donate the addition of a wing to the library building. The offer was gratefully accepted. By November, the new wing was completed. On December 8, 1952, the library trustees voted unanimously to rename the library the Lee Memorial Library in memory of William, and on January 6, 1953, Mary was named honorary advisor to the board of trustees for life.

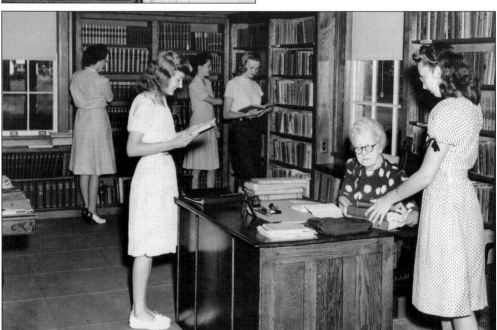

In 1946, Mary Lee, seated at her desk, would often help students find good books for reading enjoyment as well as for their school assignments. Lee was the librarian for over 30 years. In 1953, the funding for the library was assumed by the Borough of Allendale. (LML.)

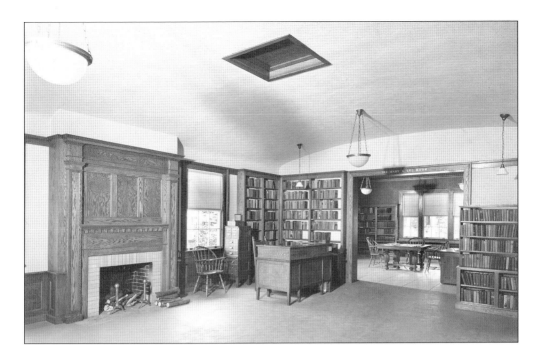

William and Mary Lee helped grow the library by donating a wing in 1941, adding space for additional books and readers. Above the doorway is a plaque acknowledging the new wing as the Mary K. Lee Room in recognition of her over 30 years as a benefactor and volunteer of the library. Looking southwest from the corner of Franklin Turnpike and West Allendale Avenue, this view shows the Allendale Public Library with its new addition. (Above, LML.)

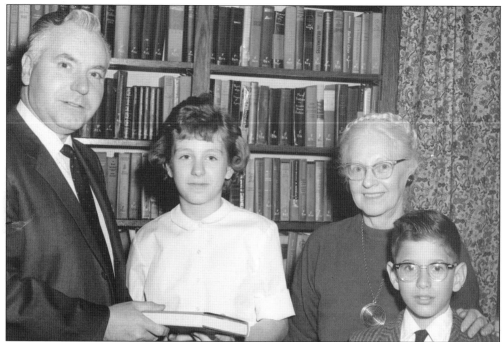

Library board of trustees president Martin Husing and librarian Hilda Sprague meet with Brookside students Karen Falcke and Peter Schoen. At the February 1, 1953, meeting of the Lee Memorial Library Board of Trustees, Husing was authorized to hire Hilda Sprague as a part-time paid librarian, succeeding librarian Mary K. Lee. In May 1967, after many years helping the library expand and prosper, Hilda Sprague retired. Grace Husselman became the new librarian.

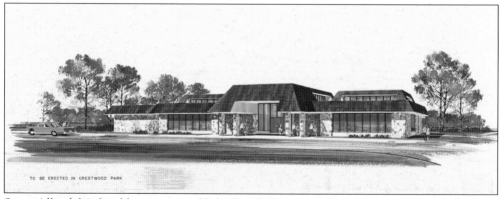

TO BE ERECTED IN CRESTWOOD PARK

Since Allendale's first library was established in 1900, its popularity has never been in doubt. It has consistently grown, moved, and then made plans to move again. Since its first home was built in 1926, it was soon looking for larger quarters. In the 1960s, the building on Franklin Turnpike was decaying, and an architect was hired to develop plans for a new location. After Crestwood Lake was purchased in 1971, there was consideration of developing a municipal complex on the newly owned property. Here is a rendering that was developed in 1974 for a new library. In 1978, as the Church of the Epiphany could no longer afford to maintain its property at 500 West Crescent Avenue, it was sold to the Borough of Allendale, becoming the new borough hall and the new home for the Lee Memorial Library in 1979. (LML.)

Five

HOUSES OF WORSHIP

On January 7, 1872, Mrs. Stephen (Emma) Cable and her daughter Mrs. James (Mary Emma) Reading organized the first area Sunday school in Mrs. Cable's parlor at 475 Franklin Turnpike. This Episcopal mission became the Church of the Epiphany, Allendale's oldest parish. Five churches now serve Allendale: Trinity Episcopal, Archer United Methodist, Guardian Angel, Calvary Lutheran, and Highlands Presbyterian.

Given the popularity of Mrs. Cable's Sunday school, a chapel was fitted up across the street in John J. Zabriskie's barn on Chapel Street, now Cottage Place. Rev. L.R. Dickinson conducted the first service. Given the need for a more suitable place, a building of Gothic design was constructed, and on June 25, 1876, the Chapel in the Willows was formally opened. In 1894, the building was moved to the corner of Franklin Turnpike and East Orchard Street. A parish was added and later joined to the church via a cloister.

In 1956, Rev. Johann Schenk came to Allendale, and the Church of the Epiphany became a full-fledged parish in 1958. With church seating totaling 110 and with Sunday morning attendance topping 200, on April 1, 1959, the church congregation voted to purchase the 10-acre Pilkington property, which bordered West Crescent and Brookside Avenues, Wehner Place, and George Street. The purchase also included an adjoining home on Brookside Avenue. The transaction was completed in May. Architects were hired to develop plans for a new church alongside West Crescent Avenue, and by 1962, the church began a building crusade to raise $271,000 for the construction of a new church and educational building. On July 1, 1964, the Reverend Kenneth A. Polglase became the new rector. The church building on Franklin Turnpike was then put up for sale. The new church was dedicated on May 15, 1965. After building a new rectory on George Street, the congregation's membership dwindled, resulting in financial difficulties. In 1979, the Epiphany sold its large brick building to the Borough of Allendale and constructed a smaller church at 55 George Street. The official consecration of the church and its furnishings was held on September 30, 1979. In 2010, the Trinity Episcopal Church was formed by the unification of Allendale's Church of the Epiphany with Midland Park's Church of the Good Shepherd. Fr. Michael Allen became the first rector, retiring in 2020.

Allendale's Archer Memorial Church was founded by O.H.P. and Mary Archer. In 1868, the Archers, regular summer residents, moved to Allendale. Because of the lengthy Sunday church trip to Hohokus, the Archers presented a new church to Allendale. On February 17, 1876, the chapel was opened for Sunday school. On June 11, 1876, the cornerstone of the Archer Methodist Episcopal Church was laid. The following Sunday, June 18, Bishop E.S. Janes officiated the dedication. A preacher who rode a circuit serving other churches was assigned to hold services

regularly in Allendale. The first full-time pastor in Allendale was Rev. William Potts George, who was assigned to the church in 1886. On November 5, 1893, an enlarged and beautified Archer Memorial Church, now including a 30-foot-by-70-foot public hall, was rededicated. The cost was $18,000, and that was donated by O.H.P. Archer, who died in 1899 at age 78. In 1901, the parsonage, the hall, and two acres of land were presented to the church by Mrs. Archer. In 1968, when the Methodist churches and the Evangelical United Brethren churches merged, the name was changed to Archer Memorial Church. Considered unsafe, the church was demolished in June 1973. On September 8, 1974, the cornerstone for the new building was dedicated. Consecration was on October 20, 1974.

The Catholic church in Allendale began in 1903. The first masses were said in Linkroum's Confectionery Store (now Allendale Liquor). Rev. P.T. Carew, pastor of Mount Carmel Church, Ridgewood, served the Catholic families in Allendale. Then, until 1913, services were held in the second-story recreation room in the Appert family's garage on Cottage Place. In December 1913, the former home of B.F. Hutches at 46 Maple Street was purchased, and simple alterations were made to convert the first floor into a chapel. The Catholic church was established in this house on December 25, 1913, and served its community until October 9, 1954. Formerly the Mission Chapel of St. Luke's Roman Catholic Church in Hohokus, the Guardian Angel Chapel was made a separate parish in January 1953. That year, the Archdiocese of Newark purchased 14 acres, including the existing buildings, of Twin Gates, the estate then owned by the Vincent Vesce family. It was located near the corner of Franklin Turnpike and East Allendale Avenue. Alterations were made, and the property opened in July 1954. Guardian Angel Church was dedicated on Saturday, October 9, 1954. The church proper and rectory occupied the main house. On November 26, 1966, the new 600-seat Guardian Angel Church building and parish hall were dedicated by the Most Reverend Thomas Boland, archbishop of Newark.

In the fall of 1954, a group of Lutheran families met together to discuss the possibility of starting a congregation in Allendale. The Allendale Borough Council was approached, and it gave permission for the use of the Allendale firehouse as a meeting space. The first service was held on December 5, 1954, with 61 people in attendance and the Reverend C.O. Pedersen as the speaker. In 1955, about five acres of property on West Crescent Avenue and Ivers Place was purchased, and in December 1956, ground was broken for a new church building. On January 13, 1957, the cornerstone of the Calvary Lutheran Church was laid, and on June 16, 1957, the church was dedicated. It consisted of an auditorium seating 200, a pastor's study, a secretary's office, a kitchen, and a fellowship room. On November 8, 1959, the Lutheran church broke ground for a five-classroom Sunday school addition and a two-story, eight-room parsonage. The Sunday school and the parsonage cost $25,000 and $23,000, respectively. The new Sunday school was dedicated on May 8, 1960.

In January 1965, Allendale members of the First Presbyterian Church of Ramsey announced plans to create a satellite church, Highlands Presbyterian, buying the Church of the Epiphany's property on Franklin Turnpike and East Orchard Street for $60,000. On June 4, 1965, title to the property of the Epiphany Episcopal Church was transferred to the trustees of the Presbytery of the Palisades. On April 1, 1965, Thomas S. Ward became the first Presbyterian minister for the Allendale church. On September 12, 1965, a total of 194 persons attended the first worship service.

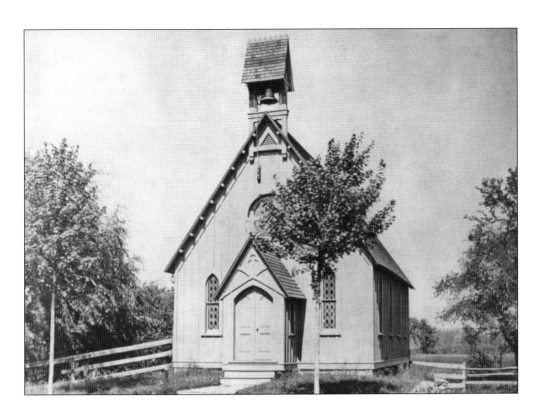

The c. 1872 photograph above is the earliest known image of Church of the Epiphany, located near Franklin Turnpike and Cottage Place. Below is a later design of the church at same location before it moved south on Franklin Turnpike near East Orchard Street in 1894. (Above, courtesy of Trinity Episcopal Church.)

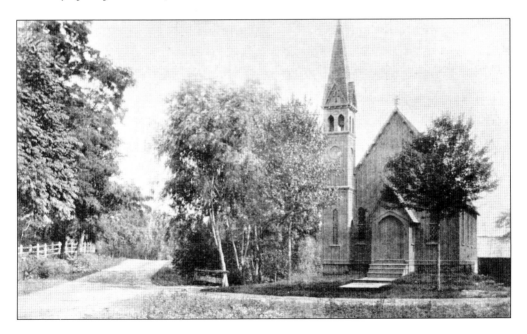

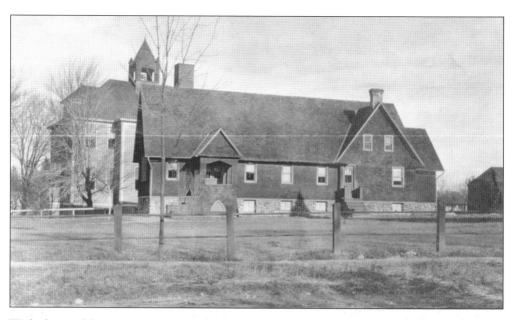

With the need for more space, a parish house was designed by and built under the direction of William Dewsnap, a New York architect who resided in Allendale and was a member of the Church of the Epiphany. Allendale's third public school, built in 1896, can be seen in the background. In 1907, the church building was enlarged, remodeled, and joined to the parish house by a cloister. The completed building is pictured below. In 1965, the church moved into newly built facilities on West Crescent Avenue. That same year, this building was purchased by the Ramsey Presbyterian Church. It would later become the home of the Highlands Presbyterian Church.

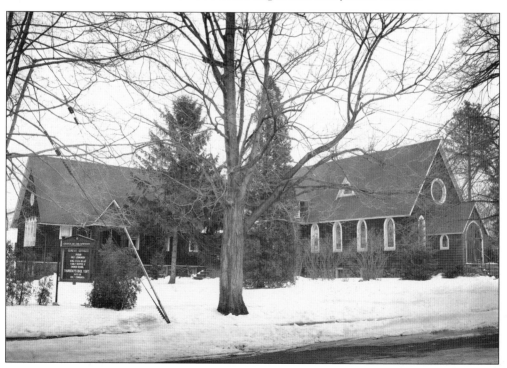

On April 4, 1965, a check toward the purchase of the present Church of the Epiphany building as a church home for Allendale's new Presbyterian congregation was presented to the Reverend Kenneth Polglase, second from left, Epiphany rector, by the Reverend John K. Highberger, pastor of Ramsey Presbyterian Church. The new church will be a mission of the Ramsey church until such time as it is self-sustaining. Looking on are Howard Ayers, left, vestry president of Epiphany, and Harry Pederson, right, steering committee chairman of the Allendale Presbyterian Church.

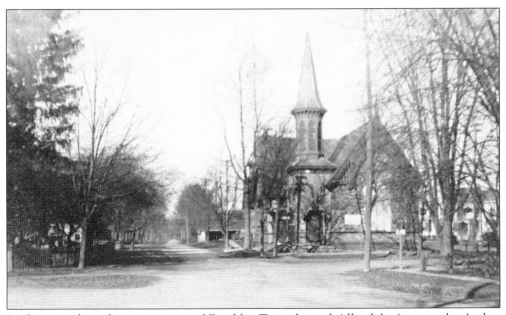

Looking north at the intersection of Franklin Turnpike and Allendale Avenue, the Archer Memorial Church is visible at right. Behind the fence at left is 2 West Allendale Avenue. A left turn would take a traveler to West Allendale Avenue toward the train depot. (AHS.)

A new Catholic church rises in Allendale at the corner of Franklin Turnpike and East Allendale Avenue. Footings and foundation are in, and the walls begin their climb above ground. When completed in 1966, it became the new Church of the Guardian Angel. (AHS.)

The cornerstone for the new Calvary Lutheran Church in Allendale on West Crescent Avenue and Ivers Place was laid during a special Sunday morning ceremony at the building site. Taking part in the program were the Reverend C.O. Pedersen, president of the Atlantic Circuit of the Evangelical Lutheran Church; the Reverend Luther R. Keay, pastor of the church; P. Daniel Freyland, first chairman of the church; Ray Hensen, Sunday school superintendent and chairman of the board of trustees; and Arne Gustavson, senior deacon. The building, scheduled to be completed by Easter, would have an auditorium for 225 people, an office wing, and a Sunday school section. (AHS.)

Six

SAFETY, SERVICE, AND SACRIFICE

In the 1890s, Allendale had no organized ambulance, fire, or police departments. Residents were encouraged to make their own arrests, neighbors used buckets and axes to put out fires, and doctors rushed to help the sick and injured.

Organized first aid came to Allendale in July 1937, when a 1926 REO ambulance was offered to Dr. Fred Kanning by the Hackensack Hospital for $1. With its first rig, the Allendale Ambulance Corps (AAC) was formed on July 8, 1937, when 13 Allendale residents volunteered for duty. Dr. Kanning was appointed surgeon to the AAC, and Paul D. O'Connor was appointed the first captain of the now 18-member squad. In 1939, at a cost of $3,500 for the ambulance and $750 for appliances, a new, fully equipped ambulance was bought with the help and advice of Dr. Harry Archer of the New York City Fire Department. The ambulance was stored in the borough garage. Located alongside the firehouse at Erie Plaza, the first ambulance headquarters was dedicated on October 20, 1940, with a later addition, completed in 1959, providing a meeting room and storage space. Originally dedicated on June 13, 1981, the new Allendale Ambulance Corps building on Franklin Turnpike near Arcadia Road was rededicated on June 13, 2008, as the John L. Alsdorf Ambulance Building in recognition of Alsdorf's 50 years of service with the corps.

In 1895, Allendale's first elected mayor and council appointed James Linkroum as the borough marshal. He was paid $25 for the year and provided with a badge and handcuffs. In 1928, the council established the borough's first police department with William J. Reimer as the chief of police. With accusations of bullying and cronyism, the council voted to disband the police department on March 14, 1939, and the marshal system returned. On January 3, 1959, the mayor and council voted to reestablish the Allendale Police Department (APD), appointing Robert D. Wilson as chief of police and Frank A. Parenti Jr. as police sergeant. Upon Chief Wilson's retirement, Frank Parenti was sworn in as police chief on June 1, 1967. Anne Kanze became APD's first female officer on August 9, 1979, and in 1980, the K-9 unit was established with officer Andrew Baum working with his new partner Guardian, a German shepherd. Robert Herndon and George "Chip" Scherb followed Parenti as police chief on January 4, 1990, and May 12, 2011, respectively. The police chief's home typically served as police headquarters. Chief marshal Kenneth Booth's home on West Maple Avenue was considered police headquarters during his tenure in the 1940s. The first Public Safety Office was established in 1951 across from the Allendale Hotel at 126 West

Allendale Avenue. In 1961, the borough took possession of the American Legion's War Memorial Building on Franklin Turnpike, providing space on the first floor for APD. In 1971, the APD rented a private home at 59 Cottage Place, remaining there until 1978, when the department moved back into 290 Franklin Turnpike after the borough administration moved to 500 West Crescent Avenue. The building at 290 Franklin Turnpike was razed in 2005, and a new 9,000-square-foot police headquarters was dedicated on the same site on November 11, 2006.

With no water system, early firefighting consisted of helpful neighbors who quickly brought shovels and axes and formed bucket brigades to bring well water. On Christmas morning 1909, two buildings on Myrtle Avenue, one owned by Max Scholz and the other by William J. Kornhoff, burned to the ground. Over the coming weeks, residents met to establish Allendale's fire department. By early 1910, a constitution for the fire department was drafted, and its first fire vehicle was ordered. It was a horse-drawn Seagrave ladder truck, which was stored in Valentine Braun's barn by the Allendale Hotel. Large circular rails were strategically placed throughout the borough that could be rung when the fire department was needed. The metal rails were hit according to a code to identify the location of the fire. When marching in local parades, Allendale firemen would often wear white suits and hats, resulting in their renown as the "Silk Stocking Boys." On April 5, 1913, on property provided by the Yeomans family, the laying of the cornerstone of the new firehouse at Erie Station was celebrated. The firehouse was also used for mayor and council meetings and for various community events. On March 7, 1963, boys smoking in the second-floor community room of the firehouse accidentally started a fire, resulting in its destruction from smoke and water. A new firehouse was dedicated at the same location on May 30, 1964. On Memorial Day 2018, the firehouse was dedicated in honor of Allendale fire chief George Higbie.

Beginning around 1909 and leading up to World War I, Capt. Harry Hand, a veteran of the Spanish-American War, drilled about two dozen young men in marching, handling arms, and fundamental Army tactics. Their troop, called the Bergen Guards, took part in many local parades but disbanded when the United States entered the world war. Harry Hand would later serve as borough clerk and as president of the board of education. At the September 1, 1919, Labor Day exercises at Recreation Park, 69 Allendale residents were given world war medals, including eight who had sacrificed their lives. Word War I veterans organized the Allendale American Legion Post No. 204 on December 16, 1919. First officers were Comdr. Maj. R.W. Rodman, Vice Comdr. George Buhlman, adjutant George Etesse, treasurer Russell Mallinson, and chaplain Edward Rouse. The membership committee included chairman Raymond P. Arlt, Oliver Asten, Herbert Winter, and R.V. Wall. From 1947 to 1961, the American Legion headquartered in the former school on Franklin Turnpike, modifying it and renaming it the War Memorial Building. With declining membership, American Legion No. Post 204 surrendered the building back to the board of education, who then offered it to the borough in 1961. Local Veterans of Foreign Wars Post No. 10181 was established in 1988.

As of 2020, three plaques on the monument at Memorial Park list the names of Allendale residents who made the supreme sacrifice for their country. They are, from World War I (1917–1919): Harold Cook Ackerson, Marshall Harley Couch, James Robert Hubbard, John Raymond McDermott, Gustave William Nadler, Charles Larrett Nidd, Edward Sherrard Nidd, and Harry Otto Weimer; from World War II (1941–1945): David L. Ceely, John J. Fox, Edward J. Hamilton, Eugene A. Ivers, Bruce S. MacIntyre, John A. Sawyer, Harold W. Scott Jr., and Charles A. Yeomans; and from Vietnam (1969): Rocco J. DeMercurio. On June 2, 1983, Memorial Drive was renamed DeMercurio Drive in his honor. Many of Allendale's streets are named after these heroes.

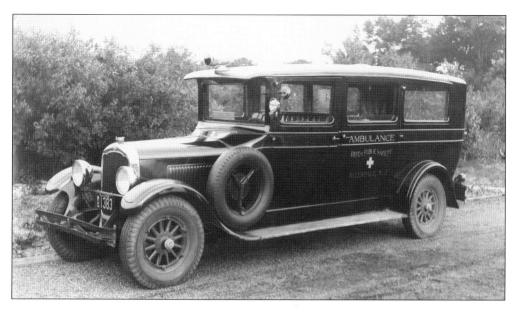

Purchased for $1, the first ambulance was a 1926 REO. Mary Stone Conklin of Hackensack Hospital asked Allendale's Dr. Fred Kanning if the borough could use its retired 1926 REO ambulance, as the hospital was buying new ones. Dr. Kanning put the matter before police chief William Reimer. "You get it and we'll drive it," said Chief Reimer. So Dr. Kanning made the arrangements, and with its first ambulance, the Allendale Ambulance Corps formed in July 1937. Carl Wehner and Paul D. O'Connor served as the first ambulance corps president and captain, respectively. Other founding members, many posing in the 1937 photograph below, included Nelson White, Henry Kahse, Cyril Dargue, Archie Farrell, Gus Sohne, Charles Bijou, Harold Ryan, Harold Kiermaier, Earl Israel, George Price, Jake Kaplan, Walter Christie, William Strangfeld, Ken Booth, Larry Scafuro, John L. Winters, William Hill, and James Kievit. (Both, AAC.)

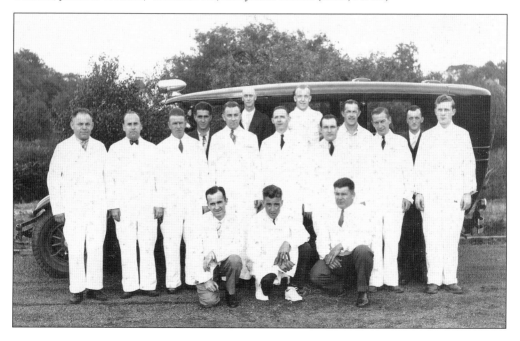

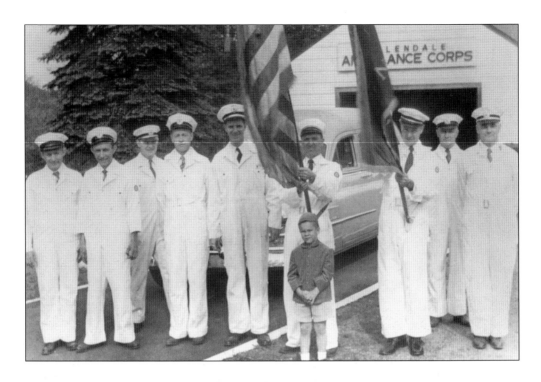

Pictured here on May 30, 1956, are, from left to right, (first row) Leonard Baum III; (second row) Bobby Straut, Pete Stanchak, Jack Comley, Roy Dietert, Bob Judson, Hank VanderWerff, Bob Taylor, Leonard Baum Sr., and Frank Kiel. They are standing in front of a 1950s Cadillac ambulance, which replaced the 1939 LaSalle pictured below. (Both, AAC.)

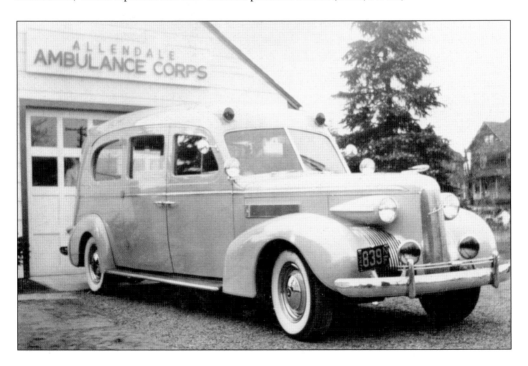

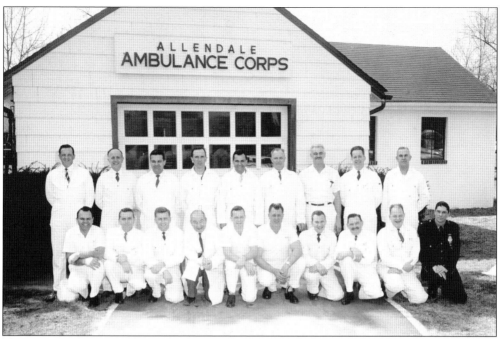

Photographed here are 1959 Allendale Ambulance Corps members. They are, from left to right, (first row) Frank Occhipinti, unidentified, Charlie Schubert, Archie Farrell, unidentified, Pete Cauwenberghs Sr., Charlie Guam, Emory Turnure, John Comley, and Frank Parenti; (second row) Lou Turner, Bob Warner, Joe Kiss, Hank VanderWerff, Bud Van Houten, Leonard Baum Sr., Frank Kiel, Clarence Shaw, and Andy Baum Sr. (AAC.)

Dr. Fred Kanning (seated); his wife, Ester; and Stiles Thomas (standing) are pictured here at the October 23, 1976, surprise testimonial dinner honoring Dr. Kanning for his service to the community. The sit-down dinner, with 200 in attendance, was held at the Swiss Chalet with Thomas acting as emcee. The ceremony, arranged by Mary Dixon, Eleanor Ostertag, Toni Van Houten, and Sis Thomas, was also attended by US representative William B. Widnall and former Allendale mayor Albert Scafuro, who toasted the honoree. Dr. Kanning, a longtime physician who served the residents of Allendale for many years, was essential in taking possession of the Allendale Ambulance Corps' first rig in 1937, which led to establishing the corps. Dr. Kanning served as physician for the Allendale Fire Department and for Hillside and Brookside Schools, Northern Highlands Regional High School, and the Allendale Ambulance Corps. (Courtesy of Robert L. Kanning.)

This photograph was taken at the dedication of ambulance rig No. 5, a Cadillac, in 1969. Pictured from left to right are Peter Cauwenberghs Sr., Bob Taylor, Paul Ferreri, John Coleman, Murry Kaplan, Ken Kievit, Ethel Tellefsen, John Alsdorf, Joe Kiss, Peter Cauwenberghs Jr., and Richard Warner. After having completed the standard and advanced Red Cross first aid courses, Ethel Tellefsen, age 33, shattered the Allendale glass ceiling in February 1969 when she was officially sworn in as the first female member of the corps. In 1976, Tellefsen was sworn in as president of Allendale Ambulance Corps. Allendale ambulance rig No. 11 was dedicated in her honor in 2007. The photograph below shows the Allendale Ambulance Corps members of 1999. (Both, AAC.)

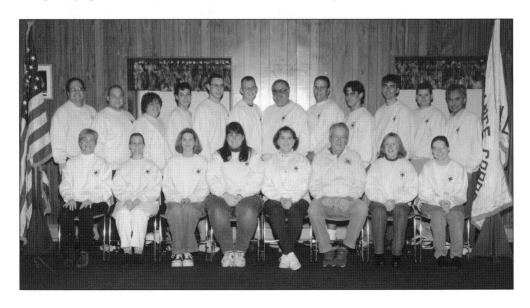

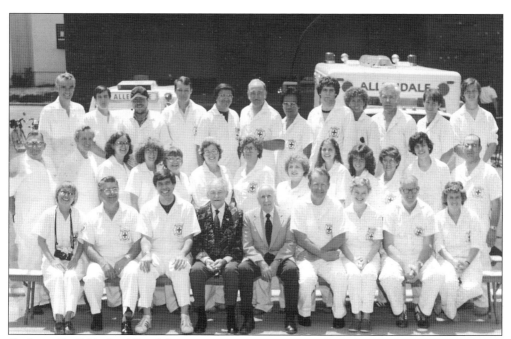

On June 13, 1981, the Allendale Ambulance Corps dedicated its new headquarters on Franklin Turnpike to serve the residents of Allendale and Saddle River. Mayor Edward Fitzpatrick of Allendale and Mayor Duncan Cameron of Saddle River addressed the large gathering. Chuck Dombeck, vice president of the corps, introduced the corps' officers. Harold Heidrich and Charles Bijou, charter members and seated at center left and center right respectively in the first row, performed the ribbon-cutting ceremony. At its January 4, 2008, installation dinner, the Allendale Ambulance Corps recognized John Alsdorf for his 50 years of volunteer service. In his honor, the corps rededicated its headquarters building as the John L. Alsdorf Ambulance Building. Previously, in 1995, Allendale Ambulance Corps rig No. 9 was dedicated in honor of Alsdorf and James Tallia. (Both, AAC.)

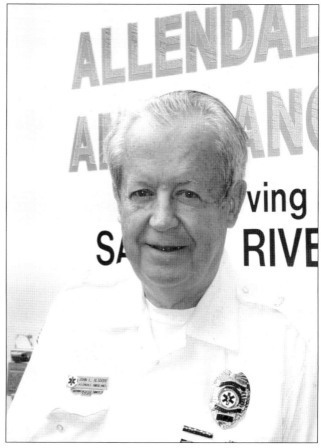

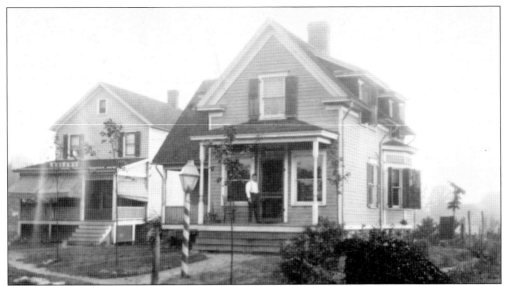

These two shops, located on Myrtle Avenue directly across from the Allendale Meat Market, changed the history of Allendale. Not because they were a bakery and barbershop, but because on Christmas Day in 1909, they both burned to the ground. For that reason, 52 townsmen, determined to create a fire department, met a few days later at Archer Hall on New Year's Eve. The Allendale Fire Department was organized the following year.

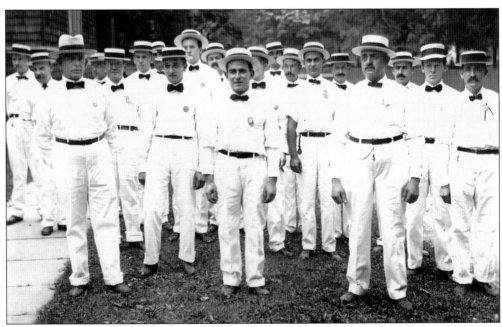

On July 4, 1910, fire department volunteers made their first public appearance in a Ridgewood parade. To make an impression, they appeared in the parade dressed in white duck trousers, white shirts, black belts, black shoes, black bow ties, white straw hats, and gloves, and they carried canes. As a result, the Allendale Fire Department was called the "Silk Stocking Boys" for many years.

Allendale N. J. 1909
December 31, 1908 1909

A citizens meeting was held on above date in Archer Hall for the discussion & formation of a fire organization.

Rev Mr Leech was chosen President and John Yeomans, Secretary

The question of fire organization was discussed and a motion was made and seconded that a committee be appointed to report on all the details of organization, cost etc, Moved and seconded that a committee of seven be appointed

Nominations.
John Hamilton
William Dewsnap
Walter Steele
H. B. Leech
Dr. Rodman,
Geo S. Quemard
Wm Mallinson
Committee.

Mr. Talman spoke briefly and recommended to the Com. a second hand apparatus, Another suggestion for committee to consider was a two wheel or four wheel apparatus. Another suggestion was to connect with other fire committees of

This is the first of three pages of minutes taken on December 31, 1909, of the first meeting of what would become the Allendale Fire Association. At this meeting, a committee was established to develop the structure of a new fire department and to begin searching for a firefighting apparatus. This committee consisted of John Hamilton, William Dewsnap, Walter Steele, H.B. Leech, Dr. Rodman, George S. Quemard, William Mallinson, and John Yeomans, who acted as secretary. (AFD.)

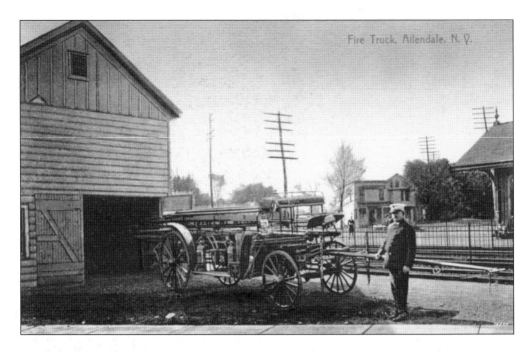

On August 8, 1910, Seagrave H. & L. Co. notified the Allendale Fire Department of the arrival of its hook and ladder truck. Valentine J. Braun, then assistant fire chief and owner of the Allendale Hotel, housed the vehicle in his barn next to the hotel. The truck was originally pulled by ropes and then by horses. A special harness, donated by Dr. Harry Archer, was hung from the ceiling of the barn and could be lowered onto the horses as they backed into position. The truck moved to the new firehouse in 1913. The photograph below shows the Seagrave ladder truck after being converted from its original design to now being powered by a Model T with chain drive, pneumatic front tires, hard rubber tires on the tractor, and original hard rubber tires under the rear trailer.

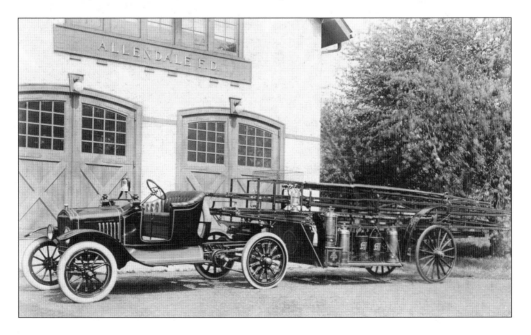

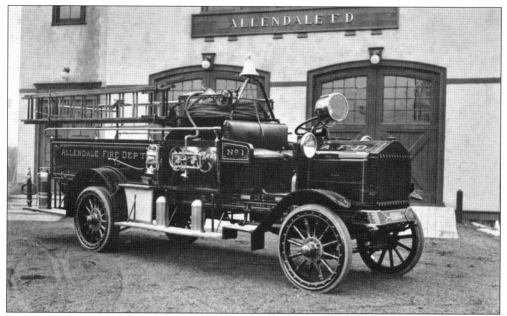

Pictured above is the Allendale Fire Department's second vehicle, a 1915 Reo chain-driven chemical truck. The next vehicle was a 750-gallon American LaFrance, purchased in 1928. It replaced the Seagrave ladder truck. (AFD.)

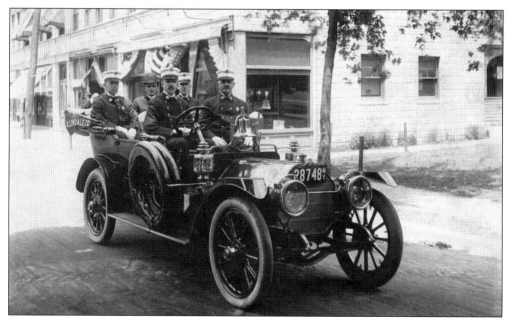

To promote the new Allendale Fire Department, honorary Allendale fire chiefs would often participate in local parades, including Ridgewood. Pictured are, from left to right, (front seat) Dr. Harry Archer and fire chief Valentine Braun; (back seat) fire association president William Dewsnap, Rev. J.W. Jackson (Church of the Epiphany), and fire chief Sam Brower. (AFD.)

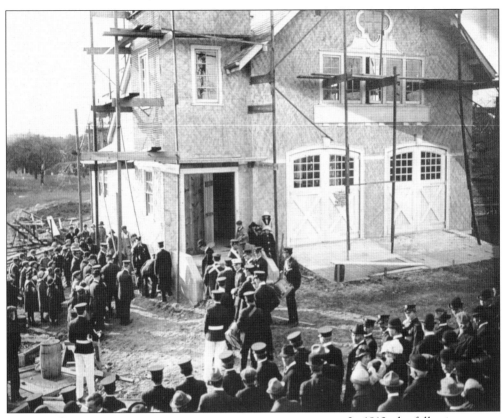

In 1912, the following people provided the needed resources for a new firehouse headquarters: John and Margaret Yeomans donated the lot, William Dewsnap provided the building plan, and S.T. Van Houten was chosen to erect the building for $6,712. On April 5, 1913, Allendale residents, accompanied by a brass band, celebrated the laying of the cornerstone for the new firehouse. Mayor John W. Winter officiated the event, assisted by the Yeomans and Dr. Harry Archer. In addition to housing its firefighting vehicles, the two-story stucco structure also had a pool table, a shuffleboard court, and a small kitchen. (Both, AFD.)

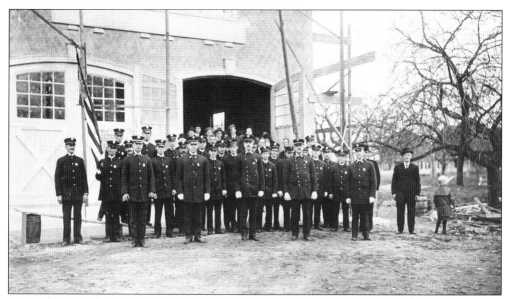

Pictured here at the firehouse dedication ceremony are, from left to right, (first row) Earnest Steele, William Dewsnap, Dr. Harry Archer, Valentine Braun, Sam Brower, and "Poppy" Mowerson (in black suit); (second row) Fred Weinier, Mac McGill, Harry Yeomans, Milton Ackerson, Edward Thomas, Frederick Koster, Charles Winters, Otto Struckler, Max Scholz, Walter Steele, and Reverend Jackson; (third row) Ing Roswell, Bert Smith, Raymond Roswell, William Schilling, Jim Mowerson, William Mowerson, Ed Hilbert, William Ackerson, Charles Johnson, and John Bijou. The rest are unidentified. (AFD.)

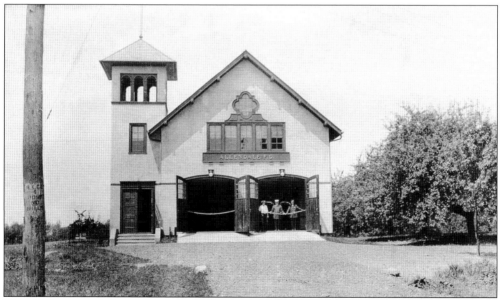

This 1913 postcard shows the completed original firehouse located at Erie Plaza. The building served numerous functions, including the council's meeting room, the borough's polling place, the official office for the Building and Loan Association, the municipal judge's courtroom, the drill hall for the Bergen Guards, and the theater for the Allendale Players. (JG.)

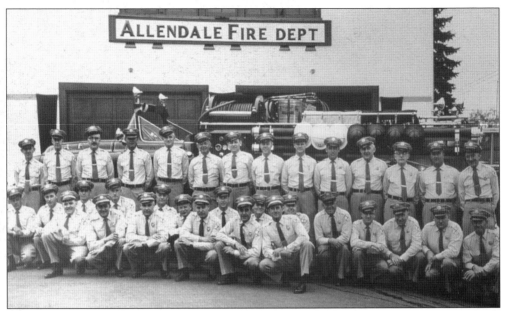

In May 1957, Allendale firemen pose in front of the original fire truck before leaving for a parade in Waldwick. In the picture are, from left to right, (kneeling, first row) 2nd Lt. Emory Turnure, 1st Lt. George W. Prince, Assistant Chief Robert Osborne, Chief Harold Osborne, 1st Capt. Everett Straut, and 2nd Capt. William Foreit; (kneeling, second row) Robert J. Tier, Howard Uhlinger, Frank Parenti Jr., David Colburn, former chief Martin Wetterauw, Lawrence Kroll, Rickard Van Houten, Harold Brown Sr., John A. Fyffe, Wilbur Vanderbeek, John Webb, Perry P. Conklin, Russell K. Stewart, and David Garrabrant; (standing) E.L. Kinter, Elwood Critchley, Henry Cobb, Donald Grosman, William Indoe, former chief Edwin W. Sr., John Turnure, William MacDonald, former chief Walter Rumsey, Andrew Kubish, B.A. Eckardt, George Wehner, and former chiefs Robert D. Wilson and Charles Ritter. (AFD.)

The new firehouse was dedicated on Memorial Day, May 30, 1964, with George W. Prince presiding as chief of the 50-member volunteer department. Mayor Robert Newman applied the cement for the cornerstone, which included a metal box containing mementos of the past as well as objects from 1964. Using the latest technology, the new fire call board would identify the street where a fire was located plus show the street location on the borough map. (AHS.)

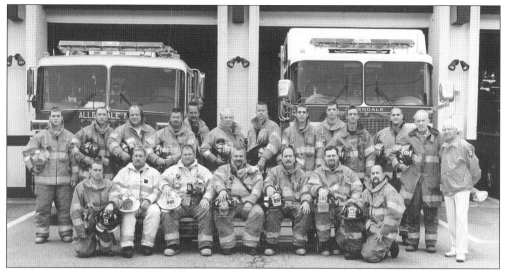

In this May 2005 Allendale Fire Department picture are, from left to right, (seated) Ryan Shute, Chief John Shute, Assistant Chief Greg Anderson, Dave Walters, 2nd Capt. Jim Moritz, 1st Lt. Layne Simon, and Dave Baez; (standing) Nick McDonough, Hans Cunningham, Tom Scott, Terry O'Rourke, Rich McDowell, Ernie Cassidy, Todd Peterson, Sean Ondich, Craig Kobovitch, Josh Beck, Kyle Cauwenberghs, George Higbie, and Bud Blide. Apparatus shown in background are Tower 941 and Rescue 992. (AFD.)

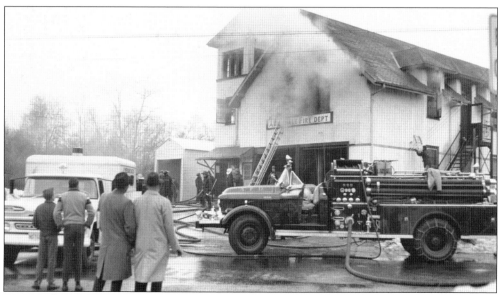

On March 7, 1963, the firehouse was gutted by a stubborn blaze. The fire was caused by four juveniles when an undetected cigarette butt fell in a closet containing plastic-covered card tables.

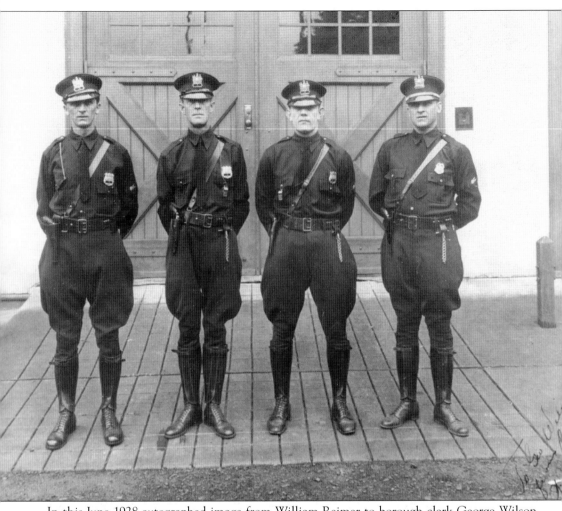

In this June 1928 autographed image from William Reimer to borough clerk George Wilson, Allendale's first and newly appointed chief of police William J. Reimer (right) stands in front of the Allendale firehouse (which served as the borough hall), with, from left to right, marshals Jay Hollenback (badge three), Mills Ackerson (badge one), and Jack Hogan (badge two). The changeover from the marshal system to an official police department occurred in 1928 with Mayor J. Parnell Thomas appointing William J. Reimer as the first police chief; he served from 1928 to 1939. Given questionable activities, the Allendale Police Department was disbanded in 1939 and replaced with the marshal system. At that time, as now former chief William Reimer had not taken the required oath to become a marshal, Mayor Keidel appointed John Oscar Forshay as the chief marshal. Forshay served from May 1939 to 1942. Given outside responsibilities, Forshay resigned, and in January 1943, Thomas Brady was appointed as chief marshal, serving until June 1945. He resigned and was replaced by Leonard Baum. Chief Baum only served until January 1946, replaced by Kenneth Booth, who served until the end of 1947. On January 6, 1948, Forshay returned as chief marshal, then took some time off, with Robert D. Wilson becoming acting chief during 1951. Forshay returned as chief marshal from 1952 to 1953, with Wilson returning as full-time chief marshal from 1953 to 1959. With the Allendale Police Department reorganized in 1959, Robert Wilson became chief of police on January 3, 1959, followed by Frank Parenti Jr. on June 1, 1967; Robert Herndon on January 4, 1990; and George "Chip" Scherb on May 12, 2011. (Courtesy of Ed and Ethel Tellefsen.)

The First National Bank of Allendale opened in 1926 at the corner of West Allendale Avenue and Maple Street. On April 7, 1938, five armed bandits committed a daylight holdup of the bank and escaped with $10,511.77. Two suspects were arrested in New York City on April 17. (JG.)

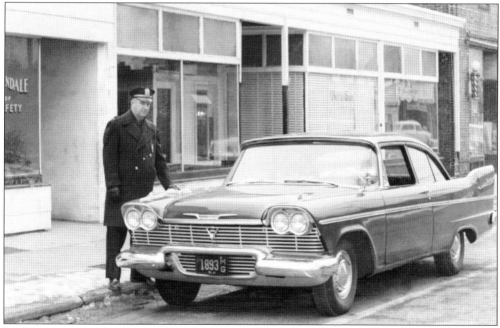

In this January 1958 photograph, chief marshal Robert Wilson shines his new fire red police car, a 1958 V-8 Plymouth. Police headquarters, often in the home of the police chief, was then located at 126 West Allendale Avenue, across from the Allendale Hotel. The borough typically purchased its new Plymouth police vehicles from H.N. Thurston & Sons Allendale Sales & Service. (Courtesy of Billy Wilson.)

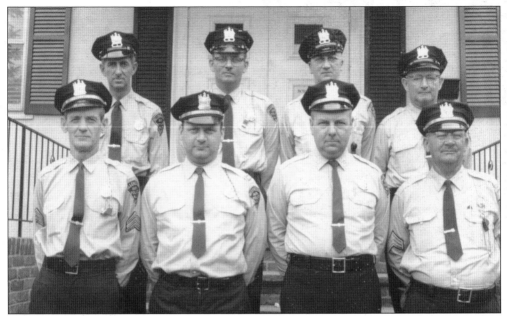

In this undated photograph, the Allendale Auxiliary Police stand in front of 290 Franklin Turnpike, the location of the current Allendale police headquarters. Pictured are, from left to right, (first row) Robert Rossner, Frank Doolittle, Robert Taylor, and Les Hudson; (second row) Calder Estler, unidentified, George Feurerstein, and Arden Bradley. The Allendale Auxiliary Police got its start in 1951 when Mayor Lester Johnson and Commissioner Henry Cobb authorized chief marshal Robert Wilson to form the group with a dozen volunteers to bolster civil defense. (Courtesy of Jeff Doolittle.)

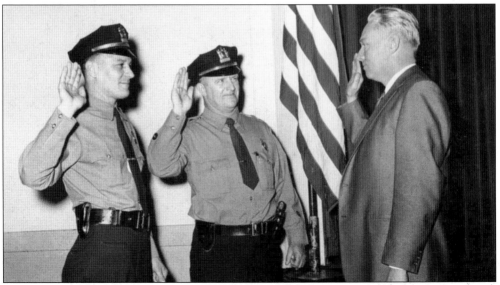

On January 3, 1959, the Allendale Borough Council unanimously approved Resolution No. 13 to restore the Allendale Police Department. At the firehouse, newly elected Mayor George A. Dean swears in Chief Robert D. Wilson (center) and Sgt. Frank A. Parenti (left) as the new members of Allendale's reorganized police force.

On April 1, 1959, the new Allendale Police Department was fully staffed with, from left to right, officer James Tallia, Chief Robert Wilson, Lt. Frank Parenti, and officer Andrew Baum Sr. (Courtesy of Lindsey Baum Colella.)

By the 1960s, the Allendale Police Department expanded to include, from left to right, (seated) Lt. Frank Parenti and Chief Robert Wilson; (standing) officers Robert Congleton, James Tallia, Raymond Verwer, Ed Tellefsen, and Andrew Baum Sr. In 1967, Chief Wilson retired after 17 years in service. Lt. Frank Parenti was promoted to police chief on July 1, 1967.

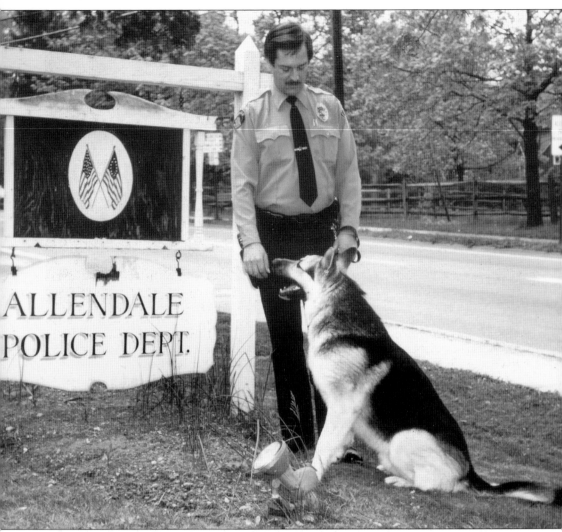

In front of Allendale police headquarters on Franklin Turnpike, officer Andrew "Andy" Baum Jr. works with his K-9 partner, Guardian. In 1969, while a student at Northern Highlands, Officer Baum started his law enforcement career as a dispatcher for the Allendale Police Department, where he worked until 1973. After earning his associate's degree in criminal justice from Bergen County Community College, he was hired as an officer with the Haledon Police Department in New Jersey, where he served until joining the Allendale Police Department in 1977. For more than 20 years, Officer Baum, son of Allendale police lieutenant Andrew Baum Sr., managed the police department's K-9 program, which he helped establish in 1980. His K-9 partners included Guardian, Axel, and Apollo. His first K-9 partner, Guardian, also known as the "Guard," served from 1981 to 1985. Guardian was born in Hawaii and trained in Bakersfield, California, before coming to Allendale. German-born and -trained dogs followed, including Axel Von Munchwald, serving from 1985 to 1994, and Apollo vom Licher-Stradtturn, serving from 1994 to 2004. Costing $4,500 each, the German-born dogs only understood German commands. When not at work, each of the dogs was the pride and joy of the Baum family. Baum, with the help of his friends and neighbors, built a dog run alongside the Baum home on West Maple Avenue. In 2004, Officer Baum retired from the Allendale Police Department, along with his partner and friend Apollo. (Courtesy of Lindsey Baum Colella.)

From 1971 to 1978, the Allendale Police Department was headquartered in a private home at 59 Cottage Place. Pictured here are, from left to right, (first row) Sgt. Martin Potter, Chief Frank Parenti, Sgt. Ed Tellefsen, and Sgt. Det. Robert Congleton; (second row) dispatcher Ethel Tellefsen, officer Jack Holloway, officer Daniel Garrabrant, and dispatcher Gail Earman; (third row) dispatcher Hank Mickiewicz, officer Robert Herndon, officer George Martin, officer Walter DeBrock, and officer Robert Leatherow. (Courtesy of Ed and Ethel Tellefsen.)

The Allendale Police Department dedicated its new headquarters at 290 Franklin Turnpike on November 11, 2006. Pictured here are, from left to right, (first row) Sgt. Todd Griffith, Sgt. Joseph Carey, Chief Robert Herndon, Sgt. George Scherb, Sgt. Al McCarthy, and dispatcher Patrick Leonard; (second row) officer Joe Galasso, officer Michael Dillon, officer Sean Hubbard, Det. John Mattiace, and dispatcher Peggy Timony. The new 9,000-square-foot building cost $3 million. (Courtesy of Gwen McCarthy.)

Beginning in 1909 and leading up to World War I, Capt. Harry Hand, a veteran of the Spanish-American War, drilled about two dozen Allendale boys in marching, handling arms, and fundamental Army tactics. Their troop, called the Bergen Guards, took part in many local parades. Once the United States entered the war, the Bergen Guards disbanded. Captain Hand later became the Allendale borough clerk and president of the Allendale Board of Education. (AHS.)

BOYS

Every Man, Woman and Child of Allendale wish for you every comfort possible, together with a most happy and speedy return HOME.

THE HOME TOWN LETTER COMMITTEE.

JAMES H. ROBERTSON, Chairman

GEORGE M. POTTER **ARTHUR TOMALIN**

A. B. SULLIVAN **SAMUEL S. BROWER**

MARSTON POTTER

In 1918, the Home Town Letter Committee was a men's group formed to send letters of encouragement and news to Allendale's finest fighting in Europe during World War I. The group typed and mimeographed its newsletter, giving pep talks and describing the exciting welcome the soldiers would receive at the "Old Erie" train station upon their return home. (AHS.)

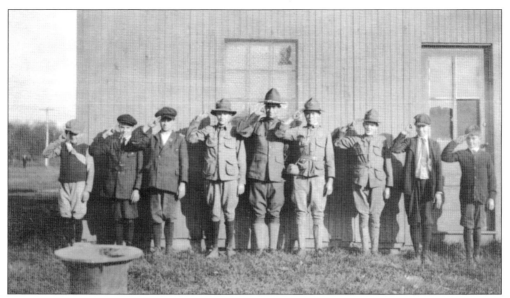

In 1917, the year that Woodrow Wilson brought America into World War I, Rev. Charles Woodruff of Archer Memorial Church formed Allendale's first Boy Scout troop, known as Troop 1. It was led by Allendale's first Scoutmaster, Robert Phair. In 1918, the Allendale Boy Scouts included, from left to right, Lodowick Rossner, William Robinson, Roland Steele, Preston Asten, Scoutmaster Harry Hartt, Walter Hillman, John Metzger, George Gaspirini, and William Taylor. (AHS.)

Pictured in 1919 is the Girl's Patriotic League. They are, from left to right, (seated) Peggy Taylor, Caroline Nealis, Mildred Boungard, Margaret McNelly, Germain Quinten, and Lenore Robertson; (kneeling) Grace Slingland, Jean Rouse, Virginia Pownell, Ruth Johnson, and Ethel Braun; (standing) Edna Grossman, Mildred Ackerson, Nancy Barnes, Gertrude Robinson, Mable Knack, Rose Holman, Adelaide Couch, Clara Nealis, Betty Anthony, Mary Robinson, May Hutches, and Mrs. Potter. (AHS.)

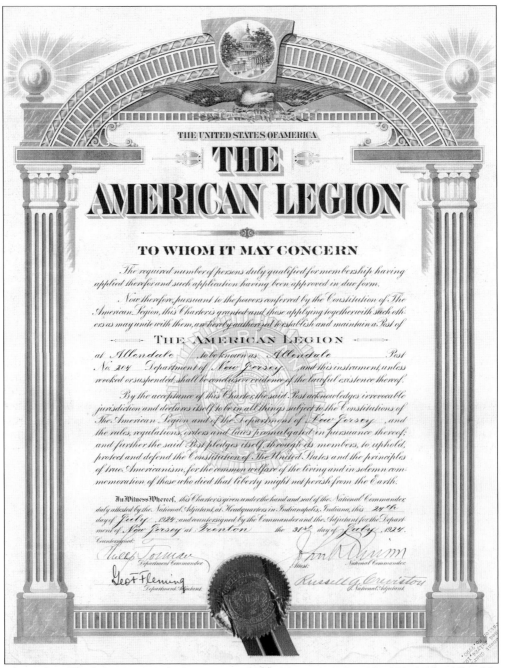

This is the official charter, signed July 24, 1924, of American Legion Post No. 204. At the Allendale Borough Hall, along with this charter, is a charter membership roll that includes the names John Van Renselear Wall, George A. Etesse, Alan M. Burtis, Robert M. Rodman, Arthur D. Mohan, Fred B. Nidd, George Hunt, Russell Mallinson, Fred S. Grossman, James S. Haulenbeck, Louis Guatelli, Charles H. Ivers, Herbert Winter, Schuyler C. Lee, and William L. Winter.

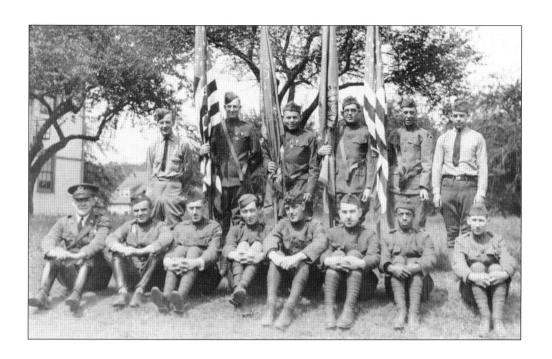

On Memorial Day, May 30, 1928, members of American Legion Post No. 204 pose near the firehouse. Pictured here are, from left to right, (seated) John Hubbard, J. Parnell Thomas, Arthur Falk, John Kelly, John Borger, Ed Hamilton, Marcy Rivers, and Russell Mallinson; (standing) Bill Winter, Arthur Mohan, Jacob Kaplan, Gene Megnin, Ingham Roswell, and George Wilson. After World War II, American Legion Post No. 204 hosted a meeting at the War Memorial Building on Franklin Turnpike. Pictured below are veterans from the First and Second World Wars, including Alwyn Grossmann and Peter L. Cauwenberghs Sr., both of Allendale. The American Legion was active in organizing annual Memorial Day ceremonies at Memorial Park. (Both, AHS.)

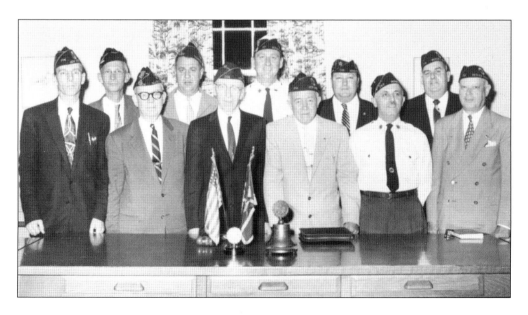

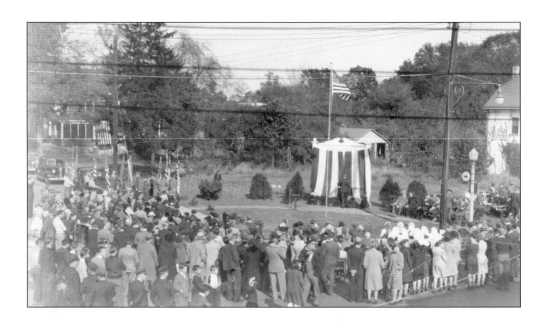

On October 18, 1942, at Pittis Field, located at the corner of West Allendale Avenue and Maple Street, the Holiday Observers sponsored the dedication of the Borough of Allendale Honor Roll, which included the names of the men and women serving in the military. One thousand people were in attendance, and Maj. John G. Hubbard and Mayor Louis Keidel spoke. Girl Scouts Janet Mohan and Jane Farley, Boy Scouts Charles Buchholtz and Richard Hover, Councilman Lyman A. Ceely representing the American Legion, and Mrs. Ernest Arlt for the Legion Auxiliary drew aside the bunting that covered the honor roll. A tradition since World War I, the honor roll has been frequently updated and displayed throughout the borough. (Both, AHS.)

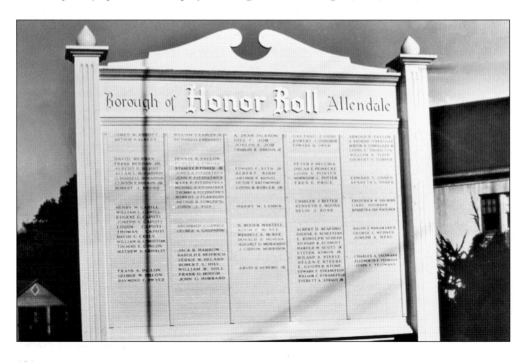

By the Authority of the Veterans of Foreign Wars of the United States:

Be it Known, that Comrades

Arthur Acampora	Raymond I. Harrison	Walter Nakoniecz
Walter P. Andersen	Robert L. Herndon	Frank A. Parenti
Ernest W. Cassidy	Bruce E. Heyler	Frank T. Pasquino
Peter L. Cauwenberghs	Robert D. Judson	Gerold T. Pryor
George P. Corniotes	Walter Lampert	Charles H. Rheinlander
Robert Cross	Dominick Mazzola	William O. Roberts
Savario De Mercurio	Donald R. Mc Naught	Robert B. Rossner
Donald B. Ferens	Henry Mickiewicz	Clarence L. Shaw
Joseph R. Fragala	Donald S. Mohan	A. Marian Strangfeld
Brian H. Gribbon	John B. Murphy	Harlan Stricklett
William E. Gronquist		John R. Tillinghast

being citizens and having served honorably in the Armed Forces of the United States of America outside its continental limits in foreign wars, insurrections or expeditions entitling them to the Award of a recognized campaign or service medal, are hereby authorized to organize and are constituted a Post in Allendale, New Jersey, to be known as

Allendale Memorial

Post No. 10181 , Veterans of Foreign Wars of the United States.

In Witness Whereof, we have hereto set our hands and the official seal of the association this 20th day of April, 1988.

Adjutant General

Commander-in-Chief

Recognizing the service of the 32 Allendale veterans named above, on April 20, 1988, Allendale Memorial Post No. 10181 Veterans of Foreign Wars of the United States was organized. Founding member Frank Parenti served as its first commander. American Legion Post No. 204 and VFW Post No. 10181 have actively participated in Allendale's Memorial Day parade and ceremonies.

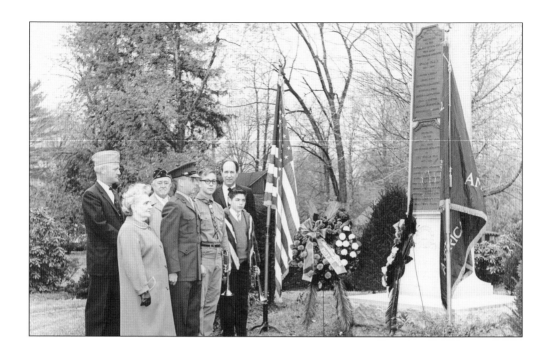

At a Memorial Day ceremony in the late 1960s, Anna Fox, gold star mother of John J. Fox, stands with John Murphy, Ernest Arlt, Gill C. Job, and others to remember those who made the supreme sacrifice. It has become an Allendale tradition on Memorial Day to bring the community together for a parade that ends at Memorial Park followed by a ceremony honoring those who have served and scarified. Below, at the 2014 Memorial Day ceremonies, World War II veterans Stiles Thomas (left) and Bernard "Bud" Blide (right) stand alongside Marine colonel Richard Jackson to salute those who have given so much for their country. (Below, courtesy of Joe Chinnici.)

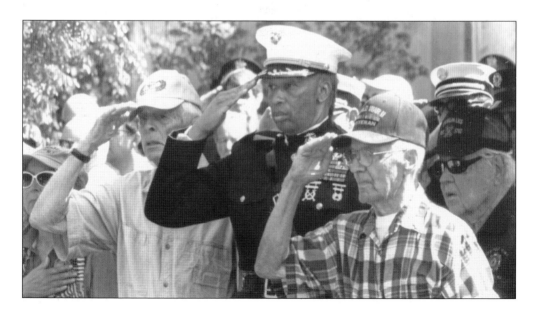

Seven

Homes, Streets, and Commerce

In the early days of Allendale, farmland was plentiful, roadways were unpaved, and streets and sidewalks were few. Landowners harvested strawberries, apples, and other items and trucked them down Franklin Turnpike to markets in Paterson. The new rail depot brought commuters who wanted modern services, including restaurants and taverns, dry goods stores, and coal deliveries. Stores and services began along West Allendale Avenue and Franklin Turnpike. Postal services began in 1869 with Smith Roswell, Allendale's first postmaster, serving mail from the train depot.

Allendale's earliest roadways were Franklin Turnpike, Allendale Avenue, Crescent Avenue, and Hillside Avenue. They connected families to community resources and farmers to markets. Established in 1806, the first road that went through Allendale was Franklin Turnpike, named after Gov. William Franklin, son of Benjamin Franklin and last of the colonial governors. The area was known as "The Turnpike." It became the first paved roadway in 1915 with sidewalks added the following year. It was along this road that the stagecoach from Albany to Jersey City ran. At the intersection of Crescent Avenue and The Turnpike, there was a little white tollhouse where a county toll was collected to raise money for the maintenance of the roads.

All roads were dirt until the county made Franklin Turnpike a Tarvia road. The early roads were lighted by kerosene lamps, and J.M. Southwick oversaw all the lamps. Farmers were appointed to take care of the roads if they really wanted to work off their taxes.

New roads and streets were constructed and named, then often renamed. East Allendale Avenue was earlier known as Saddle River Road. Cottage Place was originally called Chapel Place, as the Episcopal chapel was located there. After the chapel was moved to Franklin Turnpike, the new name Cottage Place evolved from O.H.P. Archer building cottage homes there for his workers.

Builders, property owners, and the Village Improvement Association began naming streets, including Allendale Avenue (from the train depot to Saddle River), Park Avenue (formerly Allendale Avenue), West Orchard Street (formerly Garrison Street), Broadway (southern Franklin Turnpike), and Chapel Place (now Cottage Place). The section of Hillside Avenue approaching Ramsey was called Allendale Road. While it was never implemented, First Street was considered for connection to Hillside Avenue.

Establishing and improving roads was essential to Allendale's growth as a borough. Over several meetings beginning in September 1915, the Allendale Borough Council began passing

ordinances to "lay out, open, widen, straighten, alter, vacate, and accept public streets," including Park Avenue, West Allendale Avenue, West Orchard Street, Forest Road, Myrtle Avenue, Cottage Place, Chestnut Street, West Maple Street, and Lake Street. Typically, soon after the roads were established, residents would petition the council for street lighting.

In December 1917, the council passed an ordinance that all houses in Allendale had to have numbers, and the digits were to be at least five inches in height. The houses on the right side of the road have even numerals, and the ones on the left have odd. House numbers were assigned beginning in 1925 and finally completed in 1954, when residential mail delivery began. In the 1920s, zoning of the entire borough was established with zones assigned for residential, business, and industrial purposes. In 1952, the Allendale Zoning Master Plan was adopted with an increased business zone, spurring construction of the shopping center on Memorial Drive.

Before 1937, drivers would cross over the train track on West Allendale and Park Avenues to travel from the western residential district to the eastern shopping district. Gates would raise and lower to regulate traffic as the train passed by. In 1937, an underpass was built for pedestrians, and as a result, drivers were forced to use other roadways to move about Allendale.

In June 1967, the council passed a resolution to move forward in providing sewers for the borough, agreeing to spend $25,300 for detailed plans.

Early business owners included Richard Vanderbeek Ackerman and Vito Gaspirini, who opened a dry goods store and a shoe repair shop, respectively, on Park Avenue near Erie Plaza. Businesses developed on the east side of the tracks near the intersection of Myrtle, West Allendale, and Park Avenues, often called Allendale Square. Early businesses included the Allendale Meat Market, Borger Dry Goods, and Winter Brothers. Across from Archer Memorial Church on Franklin Turnpike, the Mallinsons made cider and Henry N. Thurston ran the Allendale Garage.

A few multigenerational Allendale businesses are still going strong. Rohsler's Nursery first came to Allendale in 1925, when Austrian immigrant Herman George Rohsler purchased 100 Franklin Turnpike. Herman Albert Rohsler and Marion "Lin" Linwood-Rohsler took over the nursery in 1955 and are responsible for transforming it into what it is today. Allendale Bar and Grill, now in its fourth generation, first began when Maude Connelly purchased 67 West Allendale Avenue in the late 1940s.

A few commercial business buildings from the early 20th century remain, including the Braun Building (1911), Guatelli Building (1915), First National Bank of Allendale (1926), and the Pittis Building (1948). A few early homes along West Allendale Avenue have been converted to commercial use, including building numbers 2, 64, and 67.

In November 1962, developer Beir-Higgins completed the first phase of its nine-acre shopping center, which included a drugstore, gift shop, dry cleaning business, beauty salon, and an A&P supermarket, the mall's dominant store. The A&P later moved and expanded to a different location within the mall, but given its financial difficulties, it sold to ACME in 2015. Memorial Drive (later renamed DeMercurio Drive) was added to permit more shopping traffic.

In 1987, the development of commercial businesses along Boroline Road began with Allendale and Saddle River agreeing to pave their respective halves of the roadway.

In 1990, the council approved a makeover of the West Allendale Avenue shopping district to include paver sidewalks, additional parking, updated lighting, and removal of aboveground utility poles and wires. On June 16, 1992, the Allendale borough clock honoring Mayor Clarence "Curly" Shaw's effort to revitalize the shopping district was installed in the traffic island that intersects Myrtle and West Allendale Avenues. During 2020–2021, aided by $662,000 in Department of Transportation streetscape grants, the business district was refreshed with new, richly colored pavers, trees, and traditional-style light posts, all chosen to create a classic and timeless look.

This is the tollgate around 1900, before the hill on Franklin Turnpike was graded. The view is looking south from the intersection at Crescent Avenue. The frame building was erected in 1801, when Franklin Turnpike was constructed and opened as a toll road. The house was at the tollgate and was used for that purpose for 85 years until shortly after the coming of the Erie Railroad mainline track between Jersey City and Suffern. The house was destroyed by fire and finally razed in 1934. (JG.)

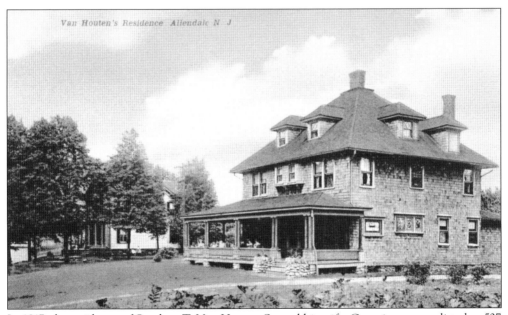

In 1917, the residence of Stephen T. Van Houten Sr. and his wife, Georgianna, was listed as 527 Franklin Turnpike. Stephen developed Crestwood Lake and served on the Allendale Board of Education. Georgianna was active in the Ladies Village Improvement Association, which was instrumental in starting the Allendale Library in 1900. This home stands today.

This is a c. 1900 photograph of 475 Franklin Turnpike. Known today as the Fell House, it was named after John Fell, who served two terms as judge of the Bergen County Court of Common Pleas during the Revolutionary War. He was a delegate in the Continental Congress in 1778 and ratified the nation's Constitution in 1787. He called the home Petersfield after his son Peter. The home is believed to have been built in the 1750s with additions in 1832 and 1912. Many families and important people have lived or stayed in this house. Joseph Warner Allen, railroad surveyor and Allendale namesake, was a guest of owner John G. Ackerman in the 1840s. Owner Mrs. Stephen (Emma) Cable and her daughter Mary Emma Reading started a Sunday school in the home in the 1870s. The Ackerman, Taylor, and Pfister families would own the home in later years. Today, the 8,000-square-foot mansion has 22 rooms, 10 bedrooms, and 4 1/2 baths. In 2007, a developer presented a proposal to the Allendale Planning Board to raze this historic home and build townhomes. Residents objecting to this project distributed leaflets and collected petition signatures to save the home. In 2008, the Concerned Citizens of Allendale was established. It raised $1.6 million, and on March 4, 2010, the Concerned Citizens of Allendale purchased the home and 2.8-acre property. Today, the Concerned Citizens of Allendale Board of Trustees, a nonprofit group, maintains this historic treasure. (AHS.)

Built in 1870, the two-story Van Houten–Yeomans Homestead (above) at 209 West Allendale Avenue is one of Allendale's oldest homes and is still standing today. The Yeomans family made considerable improvements to their home around 1885. The home remained in the family until 1955. In the c. 1915 photograph below, the Bergen Guard led the parade from Recreation Field to the firehouse, passing by 209 West Allendale Avenue. The fire department followed behind. The Bergen Guard was formed around 1909 by Harry Hand. (Both, courtesy of Doug and Ruth Ann Harris.)

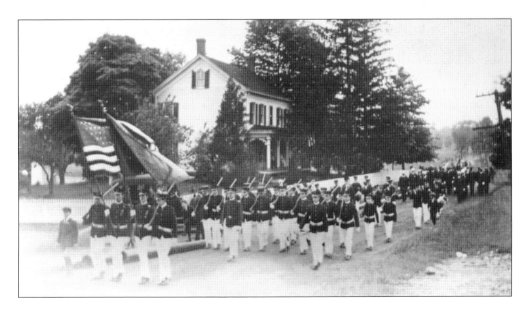

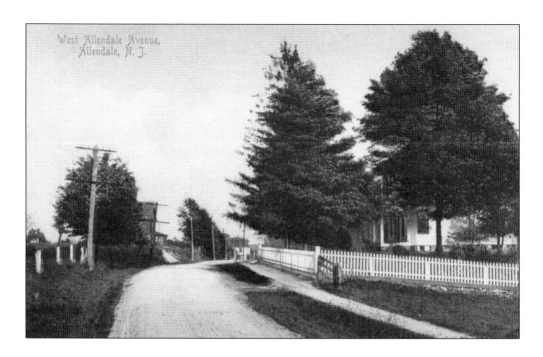

Before the railroad underpass was built in the 1930s, West Allendale Avenue had been a continuous road that allowed riders to travel from Crestwood Lake, across the train tracks, directly into the shopping district. The postcard above provides the view passing by the Van Houten–Yeomans Homestead, still standing, and headed toward the Doolittle home, no longer standing. In the photograph below, the building at right, defined by its porch, is the Allendale Hotel. The home at center was the Doolittle house. Looking closely, note the sign that reads, "Look out for the locomotive."

In this c. 1905 postcard, the view is looking south near the corner of Franklin Turnpike and Elm Street. At left, note the belfry of Archer Memorial Church. At right is the Allendale Garage. At the top of the postcard, the location is misidentified as "Allendale, N.Y." (JG.)

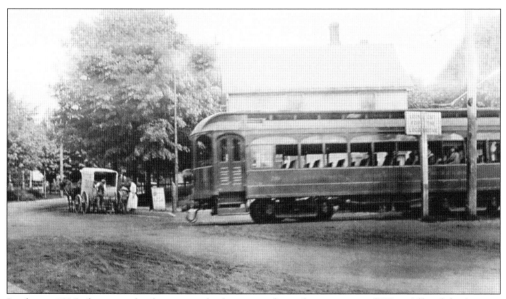

In this c. 1915 photograph, the view is looking east from the juncture of West Allendale Avenue and Park Avenue. The house behind the trolley was built by James Linkroum around 1894. In its early years, the first floor hosted an ice cream parlor, and the second floor sometimes served as a town hall, where the mayor and council meetings were held. At the time this photograph was taken, the building served as the home of Melchionna's Ice Cream Parlor, as evidenced by the ice cream sign. The truck in front of the store is an ice truck, and one nearby sign advertises ice cream. The sign at right says, "Look out for the locomotive."

Looking eastward, Russell Mallinson stands in front of the stone fence along Hillside Avenue. Behind Mallinson is the Gousset residence at 200 Hillside Avenue with its water tower (removed after 1940). Cyprian Gousset purchased the property in 1902 and had the home renovated. Gousset was in the confectionery business, specializing in chocolate-covered cherries. Years later, a famous songwriter of the 1920s and 1930s, Charles O'Flynn, lived and composed music there. (AHS.)

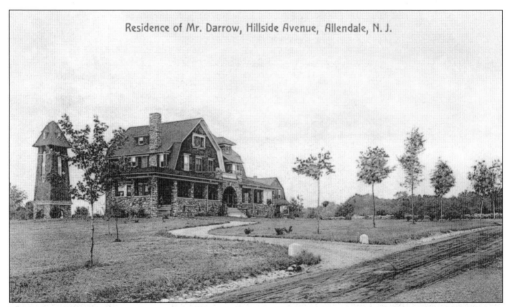

Residence of Mr. Darrow, Hillside Avenue, Allendale, N. J.

This view is looking southwest, and shown here is 205 Hillside Avenue, known as the Darrow House. Charles H. Darrow married Louise Gousset, daughter of Cyprian Gousset. Darrow was in the confectionery business with Gousset, who lived across the roadway at 200 Hillside Avenue. The water tower is gone, but this house still stands today. (JG.)

The above painting by Hillside Avenue artist and illustrator Maude Olsen details the barns on the Koole property on Hillside Avenue. This painting was presented to Dr. Aileen Wilson by Olsen during Wilson's first year as principal in 1967. It hung in the lobby at Hillside School until Dr. Wilson's retirement in 1992, whereby she took the painting with her as a memory of her many years at the school. Dr. Wilson and her family donated the painting to the school in a formal ceremony at an Allendale Board of Education meeting in 2020, and it hangs at Hillside Elementary School today. On November 30, 1965, Peter and Margaret Koole conveyed their home at 105 Hillside Avenue and 9.8 acres of their farm to the Allendale Board of Education. This property would become the home of the new Hillside Elementary School, dedicated in 1967. The property was previously owned by Daniel and Jane Van Blarcom, pictured here at their Hillside home in this pre-1900 photograph. (Above, courtesy of Greg Wilson; below, AHS.)

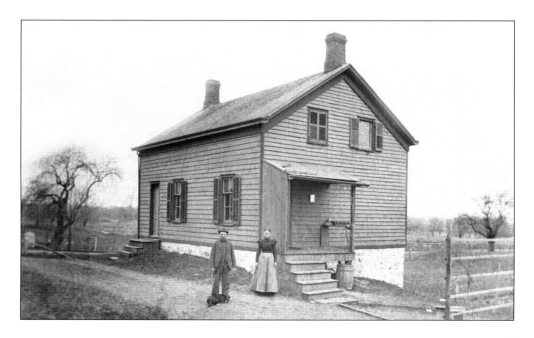

Looking south along Park Avenue around 1912, the home at right is 104 Park Avenue, built around 1875. The dirt path to the right of the cyclist would have been the original Second Street, which later became Brookside Avenue. Behind Second Street is the future Memorial Park, dedicated in 1925. The circular item hanging from the tree was a rail used as a fire alarm, banged to signal a call to the fire department. The home was owned by John J. "Jake" Pullis, a blacksmith, pictured below at his shop by the Mallinson Cider Mill, located across from Archer Memorial Church near the intersection of Franklin Turnpike and Allendale Avenue. Pullis served on the borough council from 1897 to 1898. Subsequent homeowners include the Offringa and Vennik families. (Above, JG; below, AHS.)

Pictured here are two postcards showing views of homes along West Allendale Avenue around 1900, when roads were unpaved and travel was by horse and buggy. The postcard above shows the view looking east toward Franklin Turnpike. At left is 70 West Allendale Avenue before it was torn down in 1978, and then 64 West Allendale Avenue, the home of Allendale's first mayor, Peter D. Rapelje. It still stands today. Below, at right, stands the home of Mayor George Cook, which burned to the ground in 1913. The new fire department could not save the home but was thanked for protecting nearby houses.

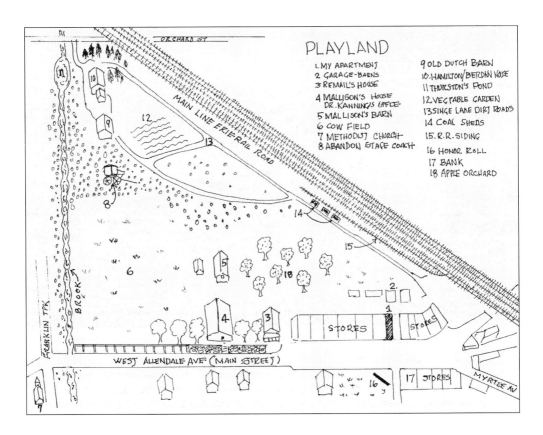

PLAYLAND

1. MY APARTMENT
2. GARAGE-BARNS
3. REMAIL'S HOUSE
4. MALLISON'S HOUSE DR. KANNING'S OFFICE
5. MALLISON'S BARN
6. COW FIELD
7. METHODIST CHURCH
8. ABANDON STAGE COACH
9. OLD DUTCH BARN
10. HAMILTON/BERDAN HOUSE
11. THURSTON'S POND
12. VEGTABLE GARDEN
13. SINGE LANE DIRT ROADS
14. COAL SHEDS
15. R.R. SIDING
16. HONOR ROLL
17. BANK
18. APPLE ORCHARD

ORCHARD ST

MAIN LINE ERIE R.R. ROAD

FRANKLIN TPK

BROOK

WEST ALLENDALE AVE (MAIN STREET)

STORES

STORES

STORES

MYRTLE AV

Drawn by Donald Brown, the above map details the homes and shops on West Allendale Avenue in the 1940s. The Garrison homestead below, later owned by the Berdan family, was torn down in the 1960s to make room for the new shopping center. (Above, courtesy of Mark Brown; below, AHS.)

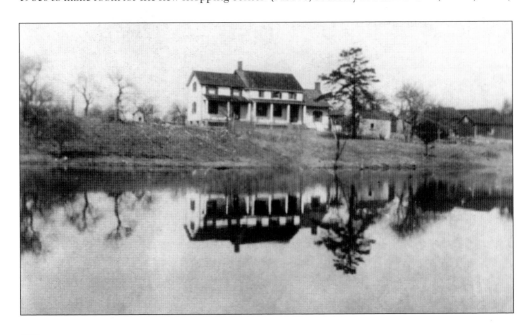

In this c. 1915 photograph, butcher James E. Simpson stands in front of his shop at 111 West Allendale Avenue, also known as the Braun or Flatiron Building. It was later the home of C.P. Plumbing, Allendale Real Estate Agency, and Stiles Thomas Insurance Agency. To meet the need for additional transportation options for local communities, a trolley was established in 1910. Looking north in the postcard view below, the trolley coming from Ramsey is stopped in front of the Guatelli Building, about where borough of Allendale clock stands today. Fatalities from its early years led to the demise of the trolley in 1929. The tracks were removed and sold to Russia. (Above, courtesy of Kyle Cauwenberghs.)

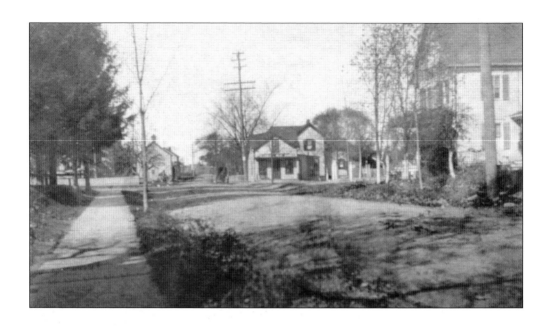

Above, the view is looking west on West Allendale Avenue around 1906. The white fence at left will be replaced by the Braun Building in 1911, and the Allendale Meat Market will be replaced in 1915 by the Guatelli Building. In 1931, to make room for the Winter Brothers Store, the house at right was moved to become 26 High Street. Below, around 1930, a view similar to the one above includes the Braun Building and Allendale Hotel at left and the Guatelli Building at center right. The streetlight in the roadway in front of the Guatelli Building is the future location of the borough of Allendale clock. Sidewalks and streetlights are present. Out of view at right is Pittis Field, named after Dr. Godfrey and Maude Pittis. The car at right is believed to belong to Doc Pittis. At right, on the corner of Maple Street, the First National Bank of Allendale was built in 1926.

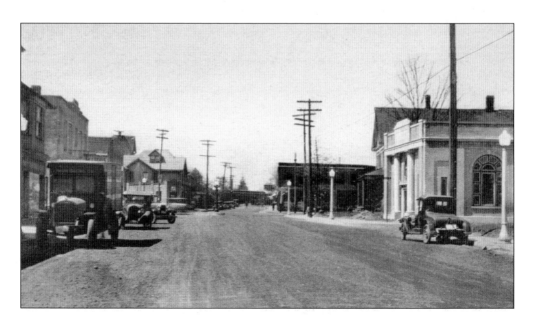

Located at the intersection of West Allendale and Myrtle Avenues, the Guatelli Building was built in 1915 by Louis Guatelli, replacing the Allendale Meat Market. Owners John and Louis Guatelli ran a confectionery shop, which was later followed by Temperlyn's Drug Store, Allendale Pharmacy, Allendale Florist, and Fino Ristorante.

The borough of Allendale clock was installed on June 16, 1992, in the traffic island at the intersection of West Allendale and Myrtle Avenues. Donations of $16,000 were provided to build the clock, which was dedicated in honor of Mayor Clarence "Curly" Shaw in recognition of his efforts to beautify the downtown shopping district. This photograph was taken in September 2020.

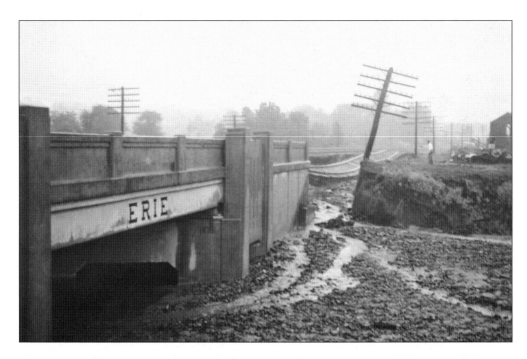

These photographs from July 24, 1945, tell the story of the destructive impact of a week of steady rain that dragged dirt and stones from Crestwood Lake onto West Crescent Avenue. Floodwaters poured down Myrtle Avenue into the business district. The Celery Farm was completely inundated and the entire crop lost. County steam shovels worked for almost two weeks to clear debris and restore train service, traffic, and local business activities. (Both, AHS.)

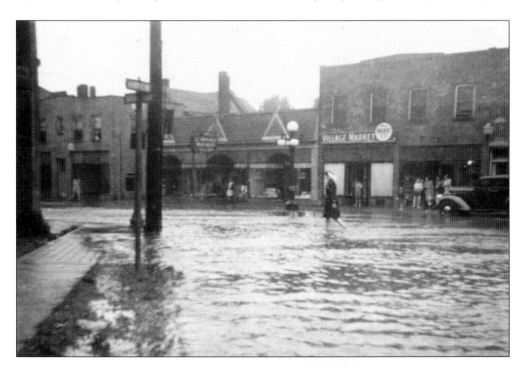

Allendale's new post office building, located at the corner of Myrtle and West Allendale Avenues, was dedicated at 2:00 p.m. on June 8, 1963. Speakers included US representative William B. Widnall (R, Seventh District), Mayor Robert I. Newman, and postal services officer William Popaca. Opened on May 27, the new building was twice as large as the previous location. With 15 employees, including eight city carriers, the post office served about 5,000 people. Below, at their counters, postal clerks show how they handle the sale of stamps and other operations connected with the mail. They are, from left to right, Herbert W. Scherb, Frederick H. Hasenbalg, and Joseph M. Fronzaglia. (Both, AHS.)

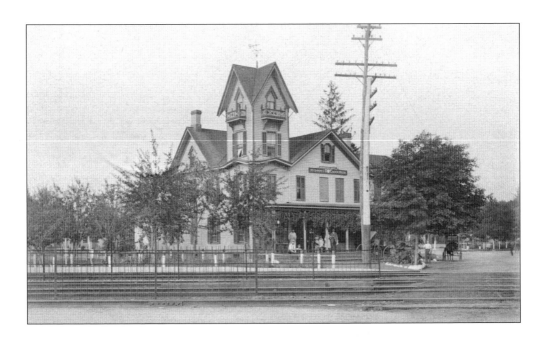

The Allendale Hotel, pictured above around 1907, was a popular place to have a good meal and alcoholic beverage. Below, from left to right on the steps of the Allendale Hotel, owner Valentine Braun watches the trains pass by with a Mrs. Jones (a neighbor); Dick the bartender; his wife, Lucy; and John Monroe. Monroe, a resident from Park Avenue, would regularly visit the Brauns on the hotel front porch to discuss the day's events. Valentine Braun helped establish the Allendale Fire Department and served as fire chief. In 1947, the Brauns' daughter, Ethel Braun Maratene, owner of the hotel, lost a battle with tavern manager Maude Connelly to keep the hotel's liquor license when Connelly left to establish a new pub at 67 West Allendale Avenue.

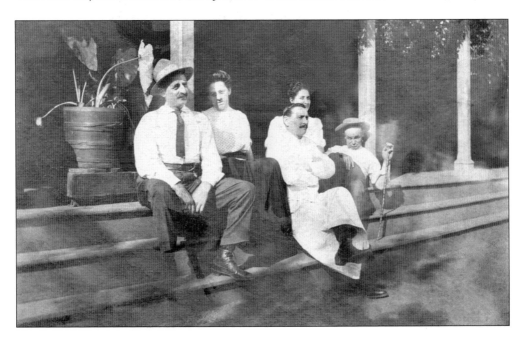

Maude "Mom" Connelly, right, works in the restaurant kitchen with one of her cooks, Casey Mahoney, to prepare an Allendale Bar and Grill favorite—pizza to go. The Allendale Bar and Grill, established by Connelly in 1947, and the Mahwah Bar and Grill, acquired in 1992, are now owned and operated by Mom's great-grandchildren Chris, Craig, and Katie. (Courtesy of Diane Coates.)

On August 9, 1974, Allendale Bar and Grill owner and bartender Walter Kunisch serves refreshments as patrons watch Richard Nixon resign on the little black and white television in the corner over the bar. (Courtesy of Chris Kunisch.)

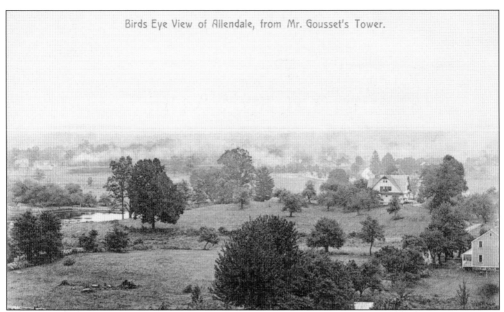

Birds Eye View of Allendale, from Mr. Gousset's Tower.

This postcard provides a bird's-eye view from Cyprian Gousset's water tower at 200 Hillside Avenue around 1905. In the background, a train bellows smoke into the air as it heads north. Mallinson's Pond, the future site of Crestwood Lake, can be seen at left. At center right is the Parkhurst–Van Houten home on West Maple Street.

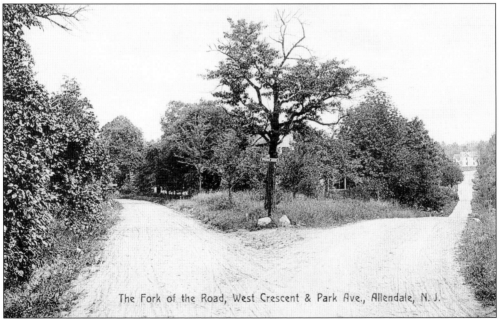

The Fork of the Road, West Crescent & Park Ave., Allendale, N. J.

Headed north on West Crescent Avenue in the early 1900s, a traveler would come across this fork in the road. Bearing left, the journey would continue along West Crescent Avenue headed toward Brookside and Hillside Avenues. The road at right, which would take the traveler northeast toward the train station, is Park Avenue.

BIBLIOGRAPHY

Brown, Donald H. *The Way It Was: A Boyhood Memoir, 1934–1948*. Bloomington, IN: AuthorHouse Publishing, 2011.

Clayton, W. Woodford. *The History of Bergen and Passaic Counties, New Jersey*. Philadelphia: Everts & Peck, 1882.

History Committee of the Allendale New Jersey Tercentenary Committee. *A History of Allendale 1894–1964*. Allendale, NJ: Allendale New Jersey Tercentenary Committee, 1964.

Van Valen, James M. *History of Bergen County, New Jersey*. New York: New Jersey Publishing and Engraving Company, 1900.

Wardell, Patricia Webb. *Allendale: Background of a Borough*. Allendale, NJ: Allendale Historical Society, 1994.

Westervelt, Frances A. *History of Bergen County, New Jersey, 1630–1923, Volume I*. Chicago and New York: Lewis Historical Publishing Company, 1923.

DISCOVER THOUSANDS OF LOCAL HISTORY BOOKS FEATURING MILLIONS OF VINTAGE IMAGES

Arcadia Publishing, the leading local history publisher in the United States, is committed to making history accessible and meaningful through publishing books that celebrate and preserve the heritage of America's people and places.

Find more books like this at
www.arcadiapublishing.com

Search for your hometown history, your old stomping grounds, and even your favorite sports team.